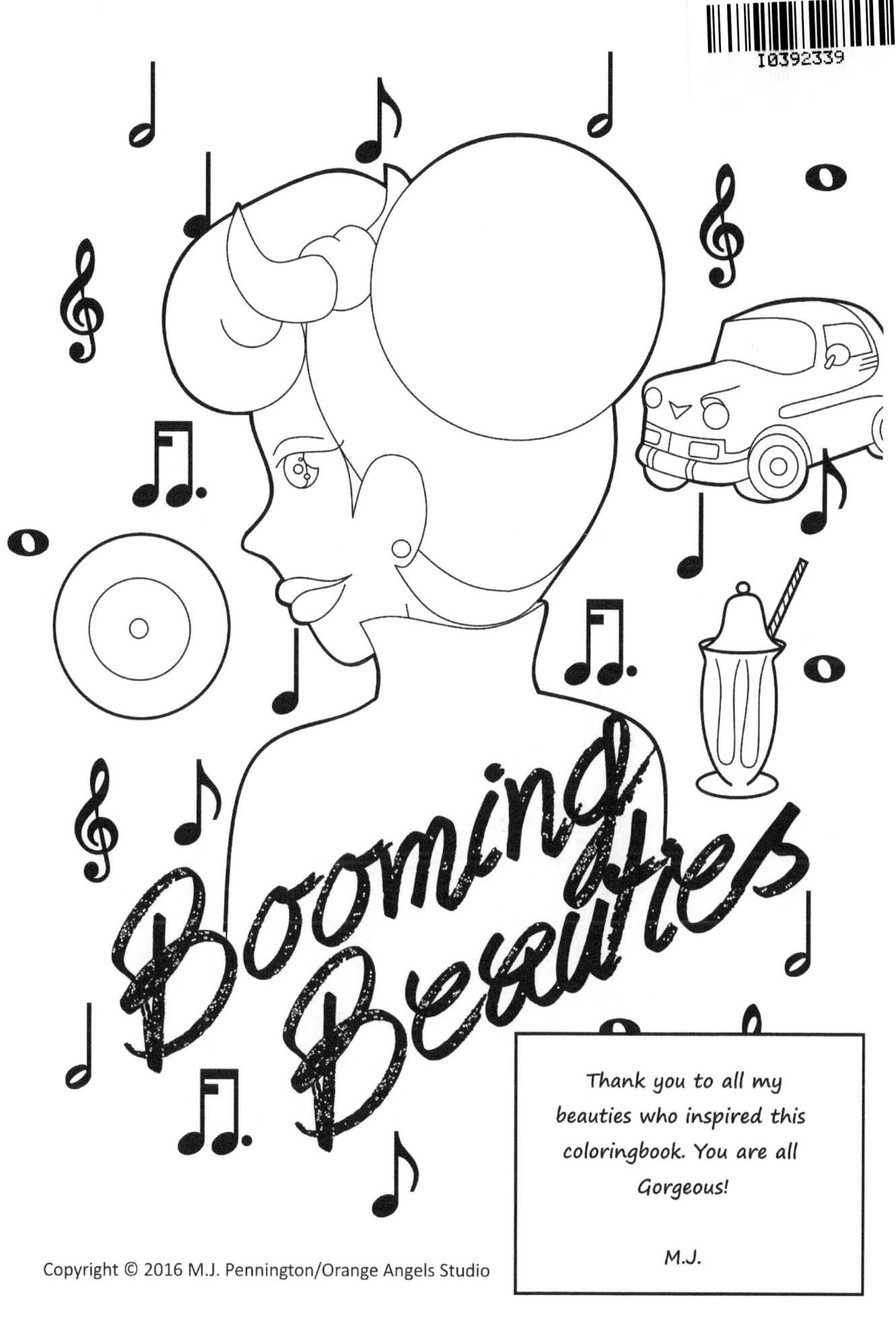

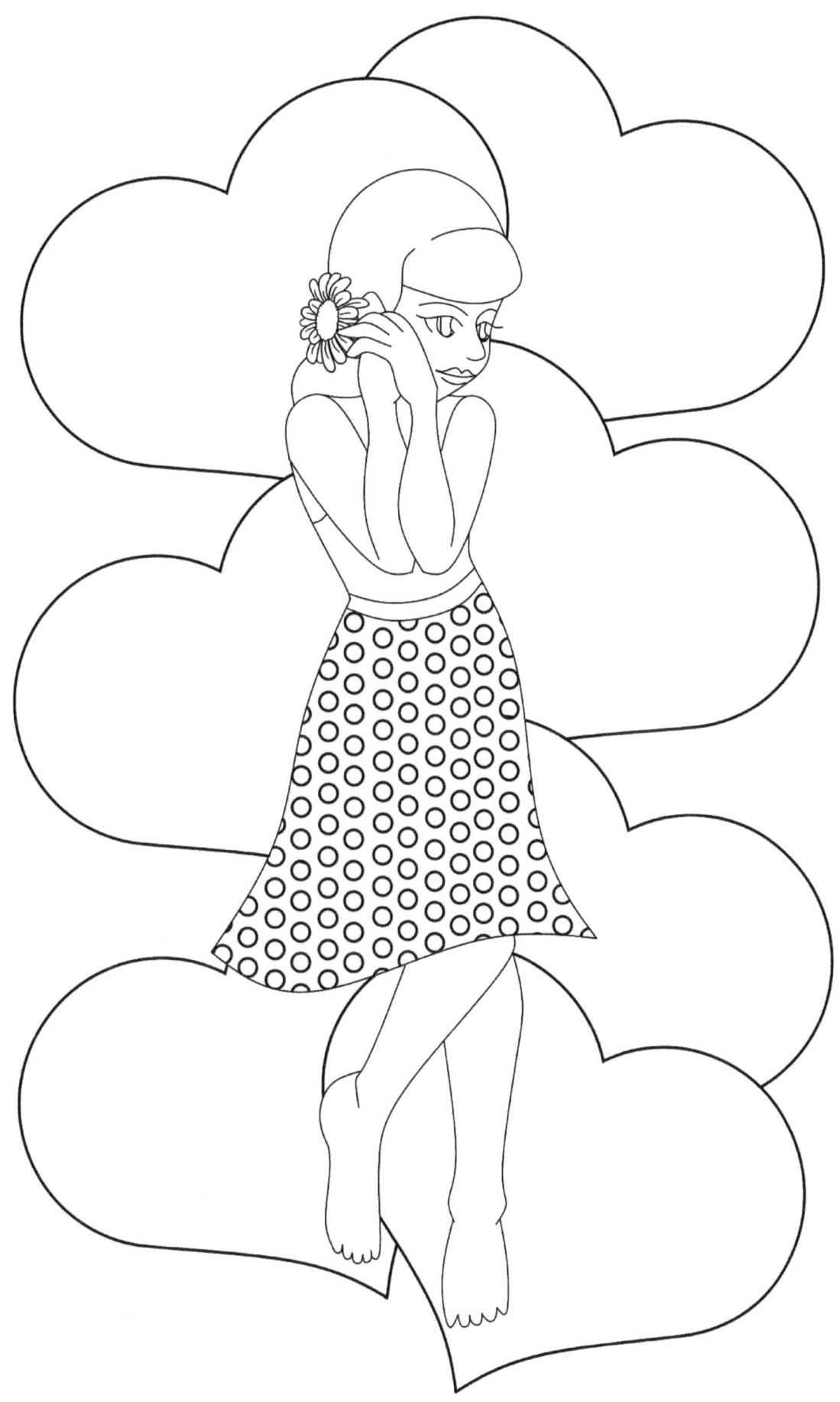

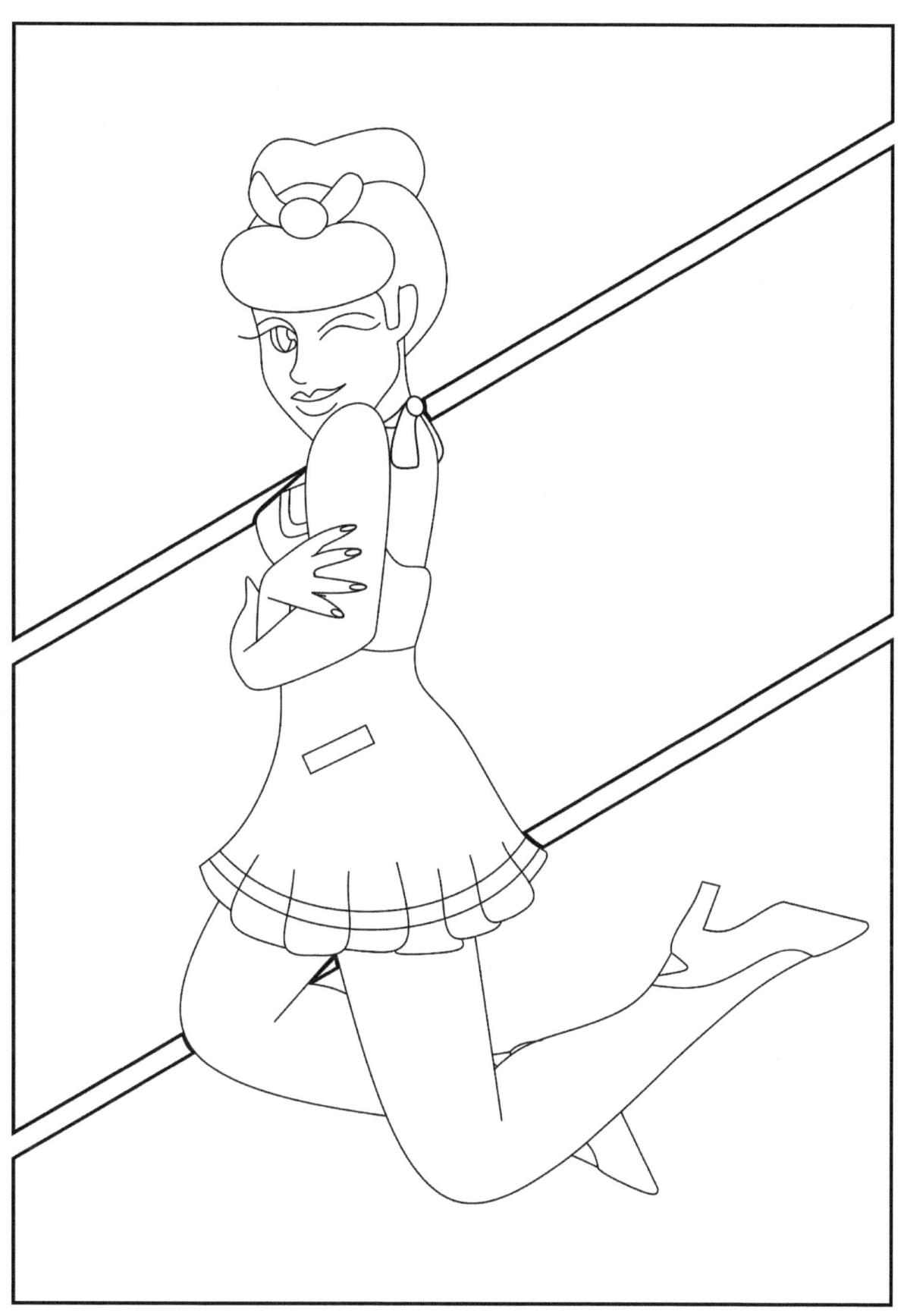

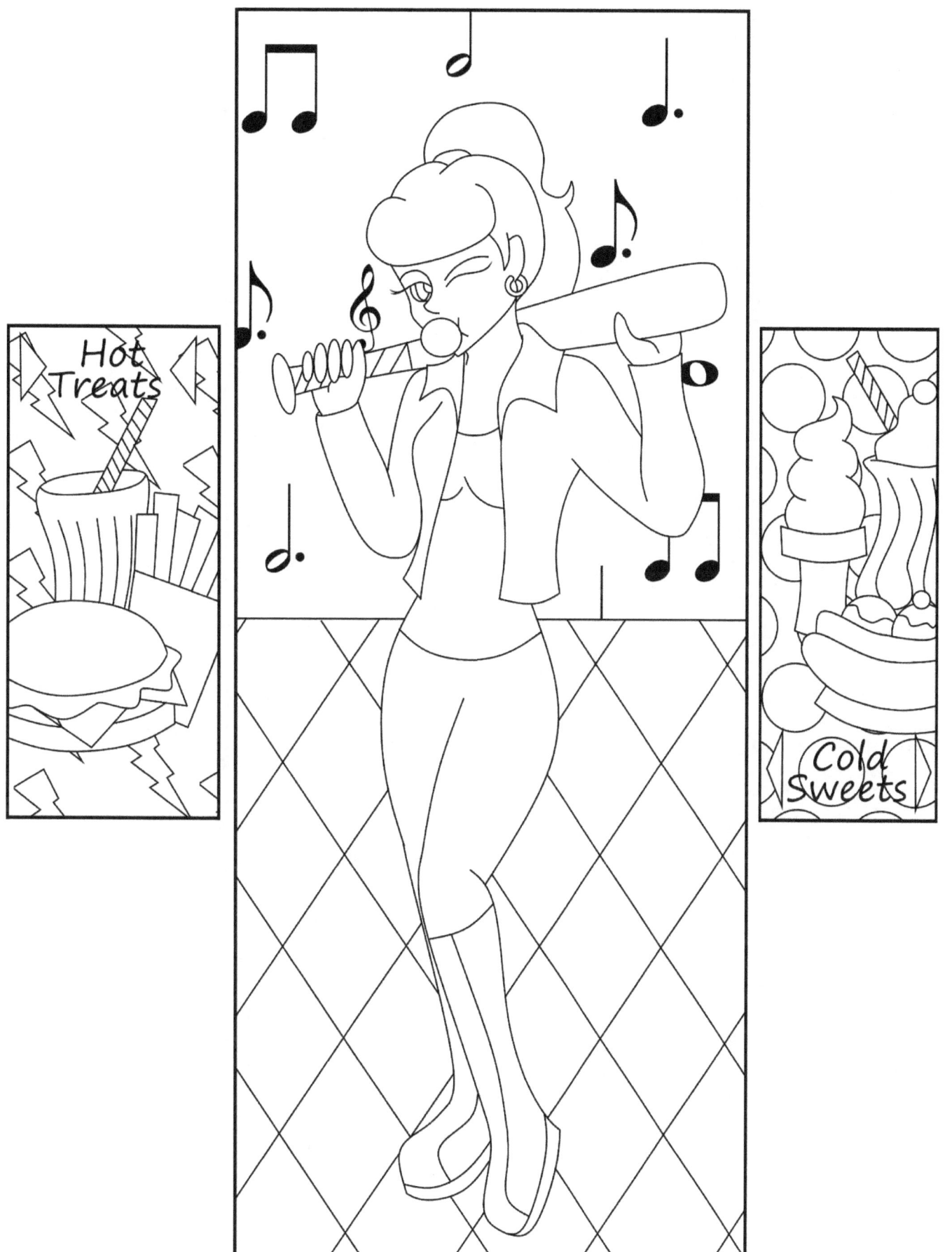

Copyright © 2016 M.J. Pennington/Orange Angels Studio

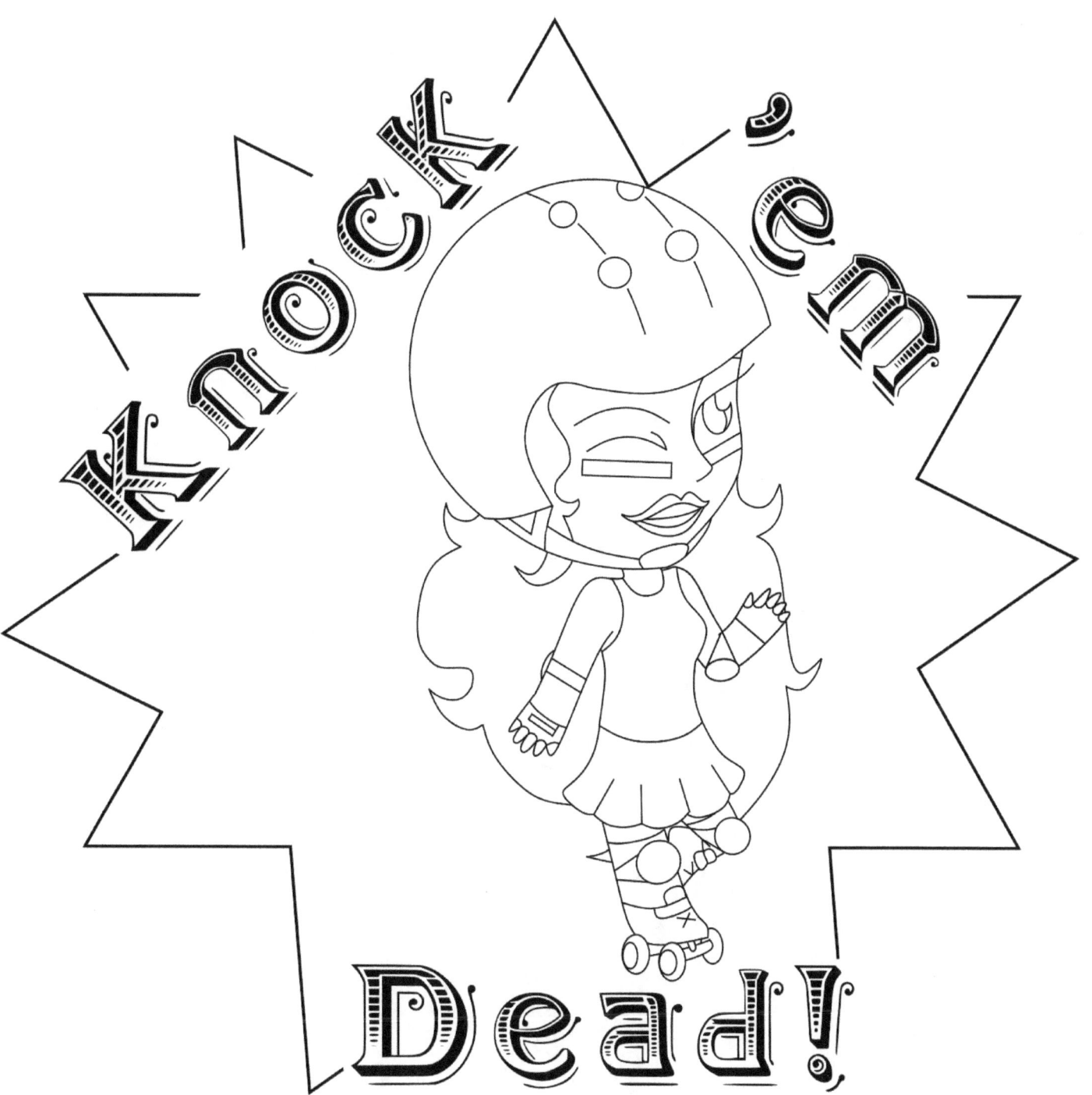

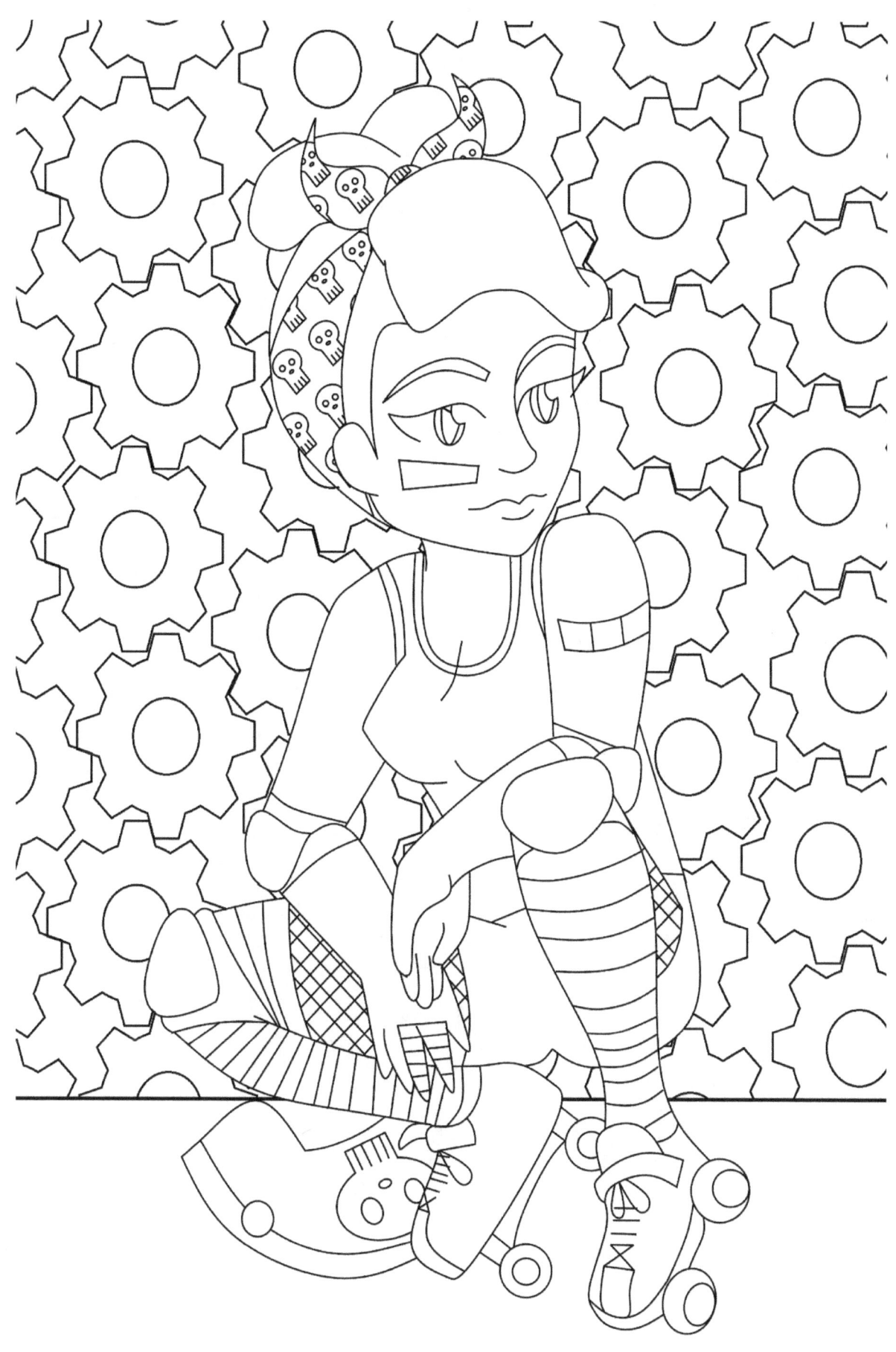

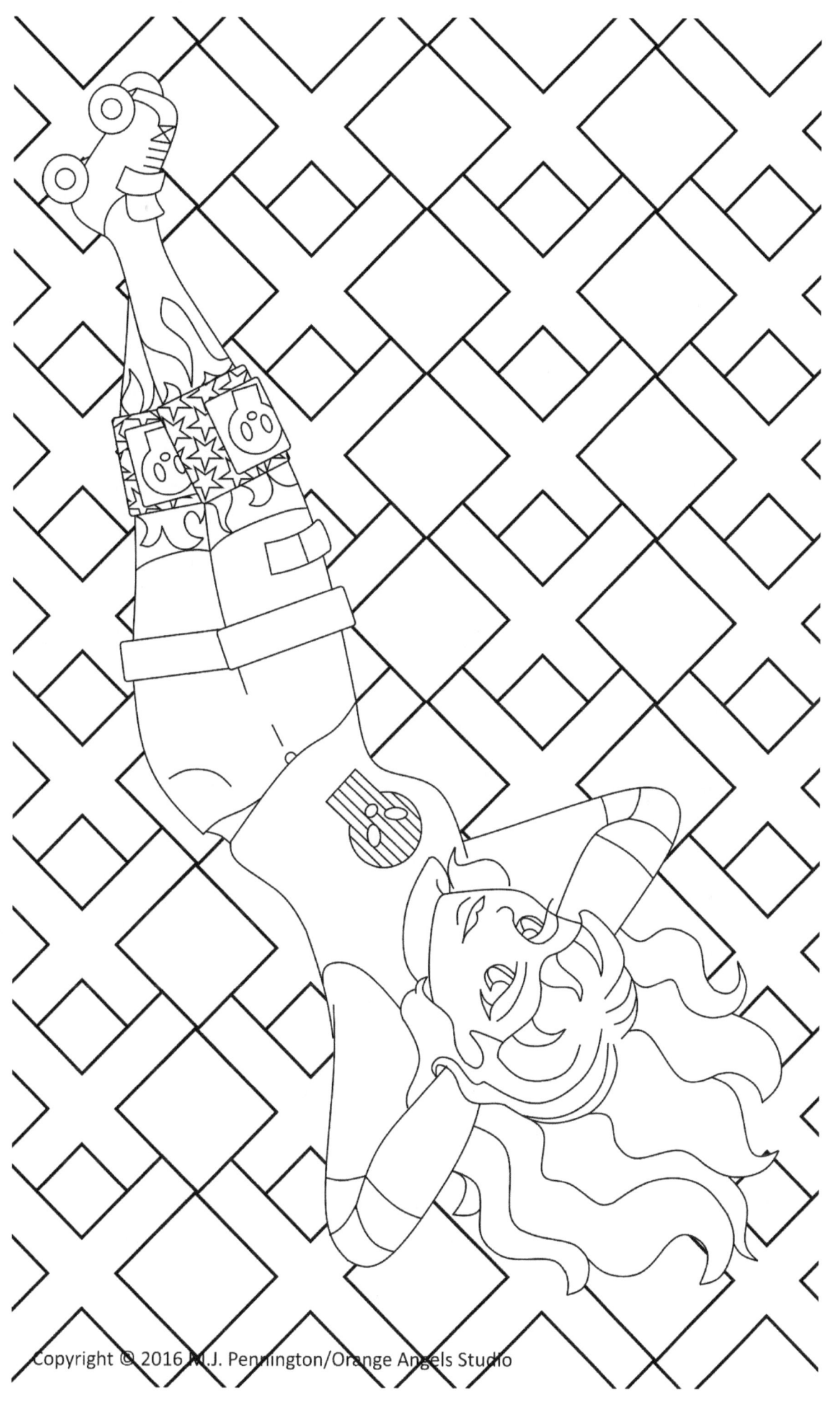

Copyright © 2016 M.J. Pennington/Orange Angels Studio

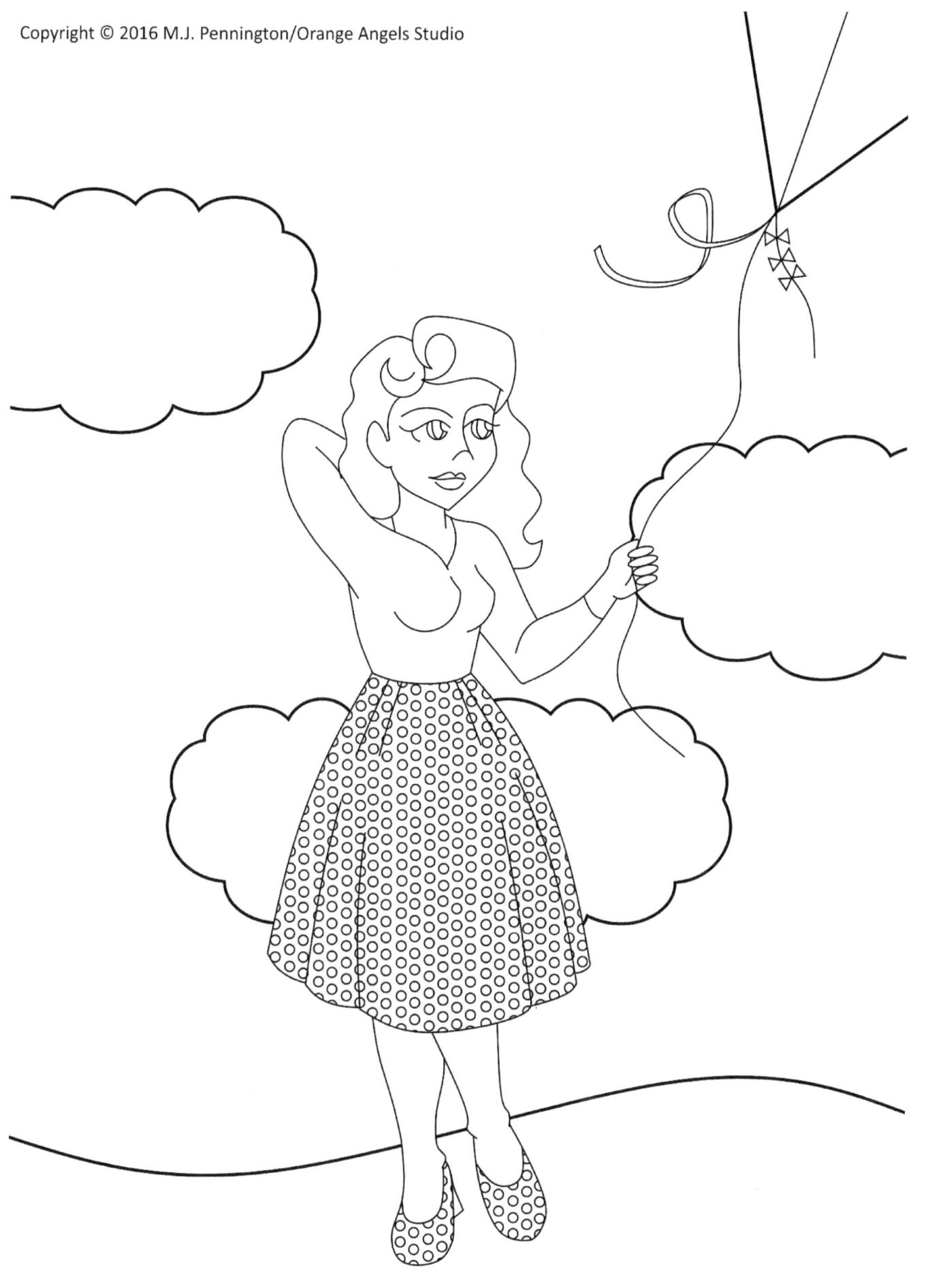

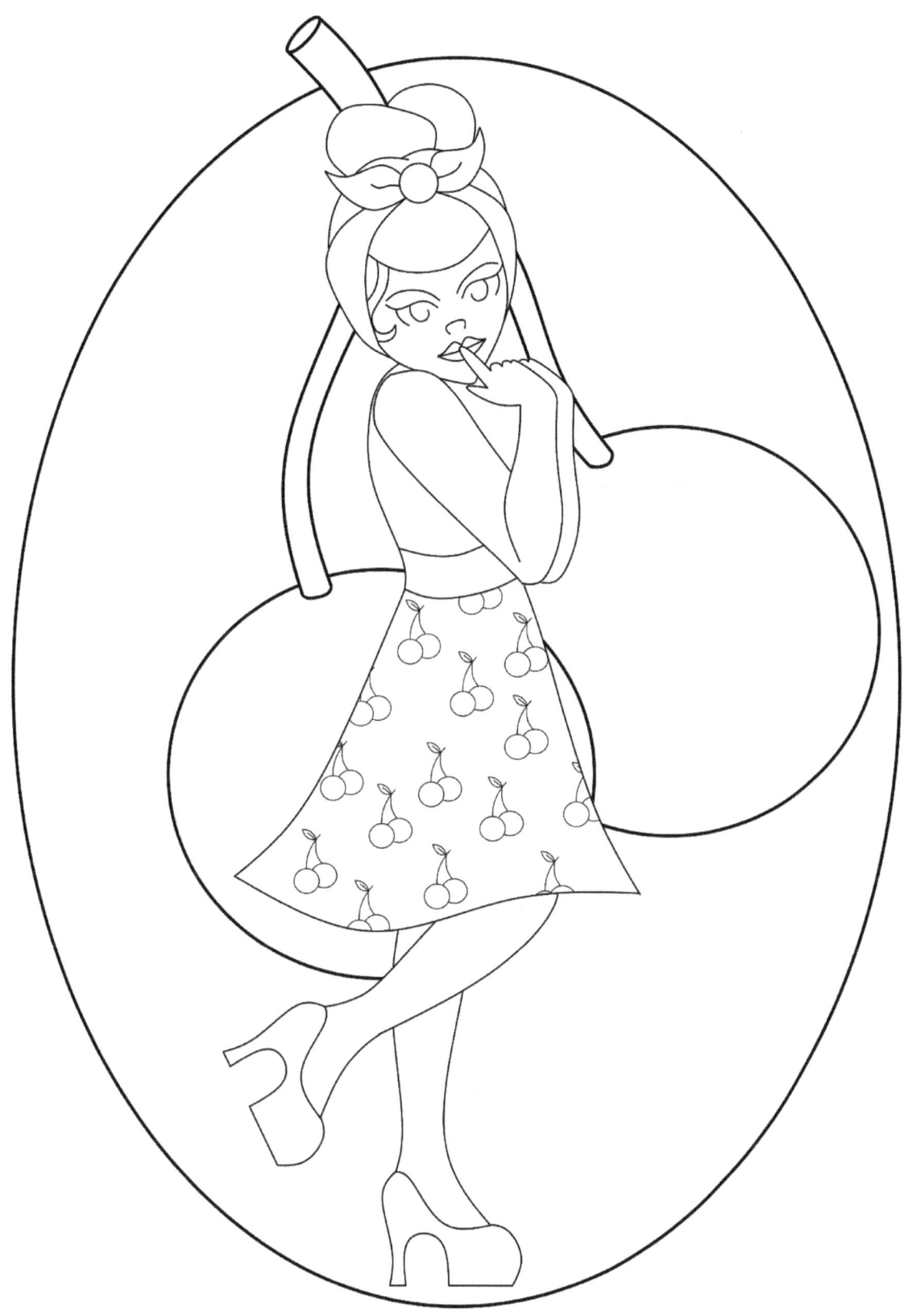

Copyright © 2016 M.J. Pennington/Orange Angels Studio

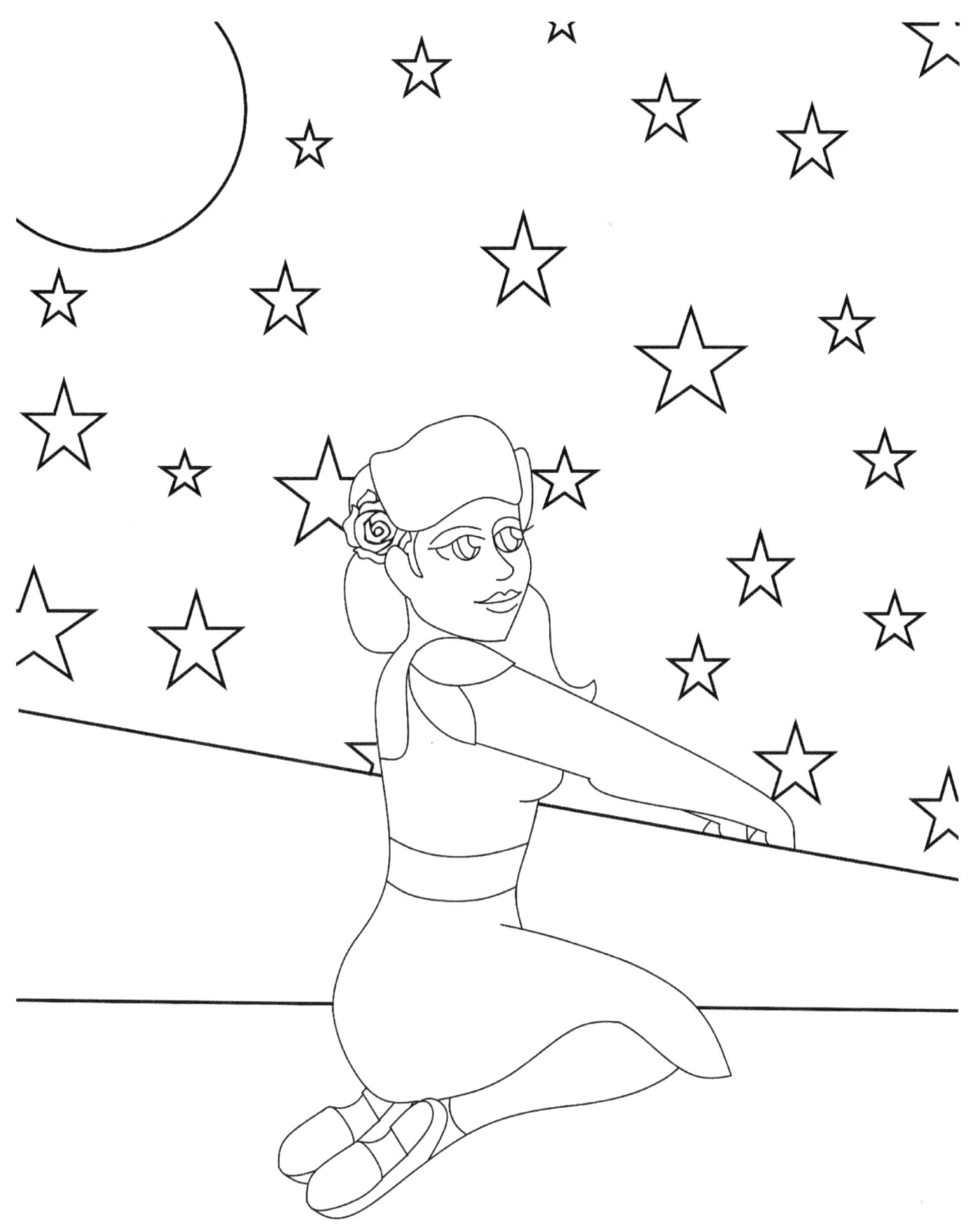

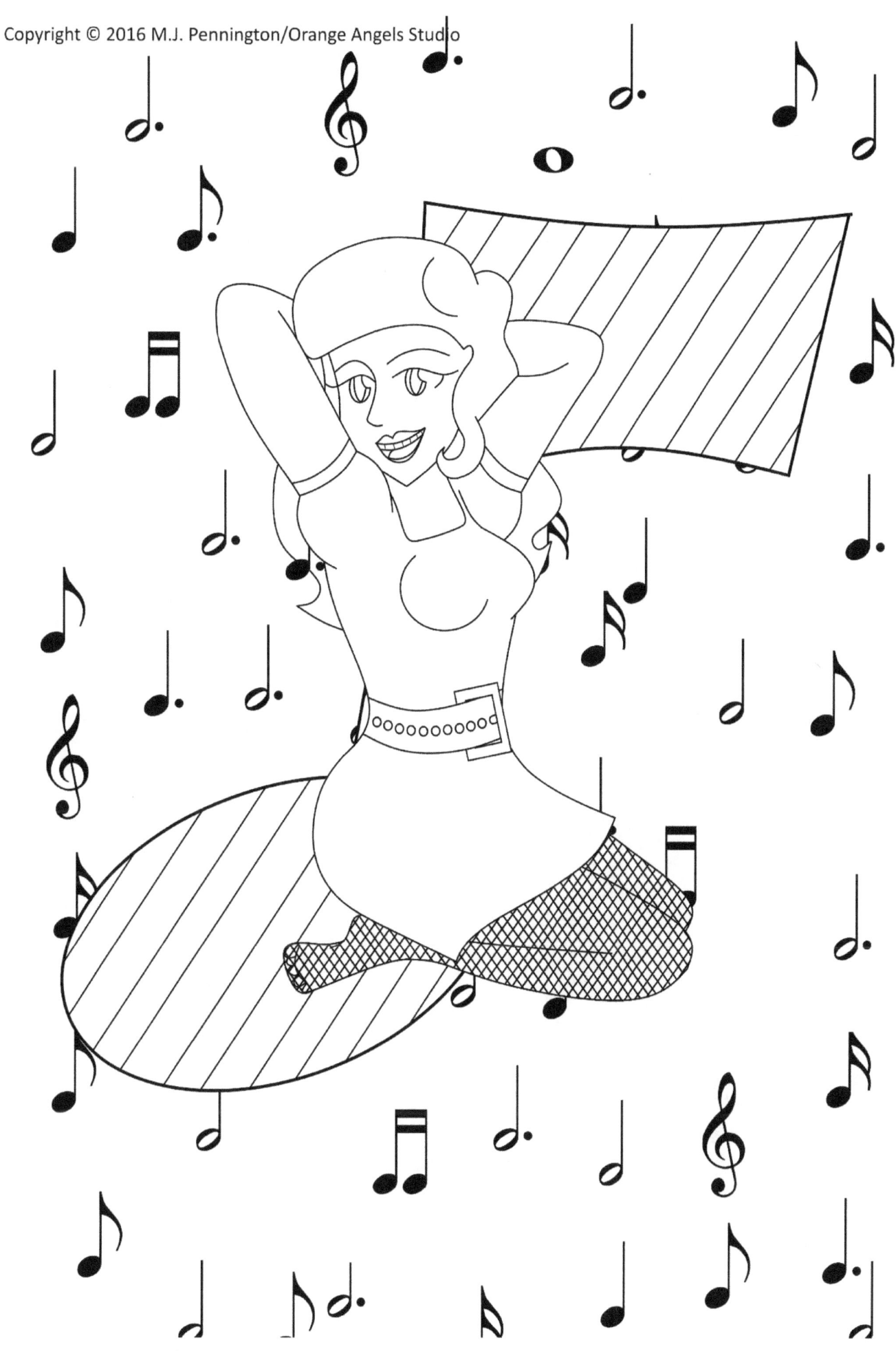

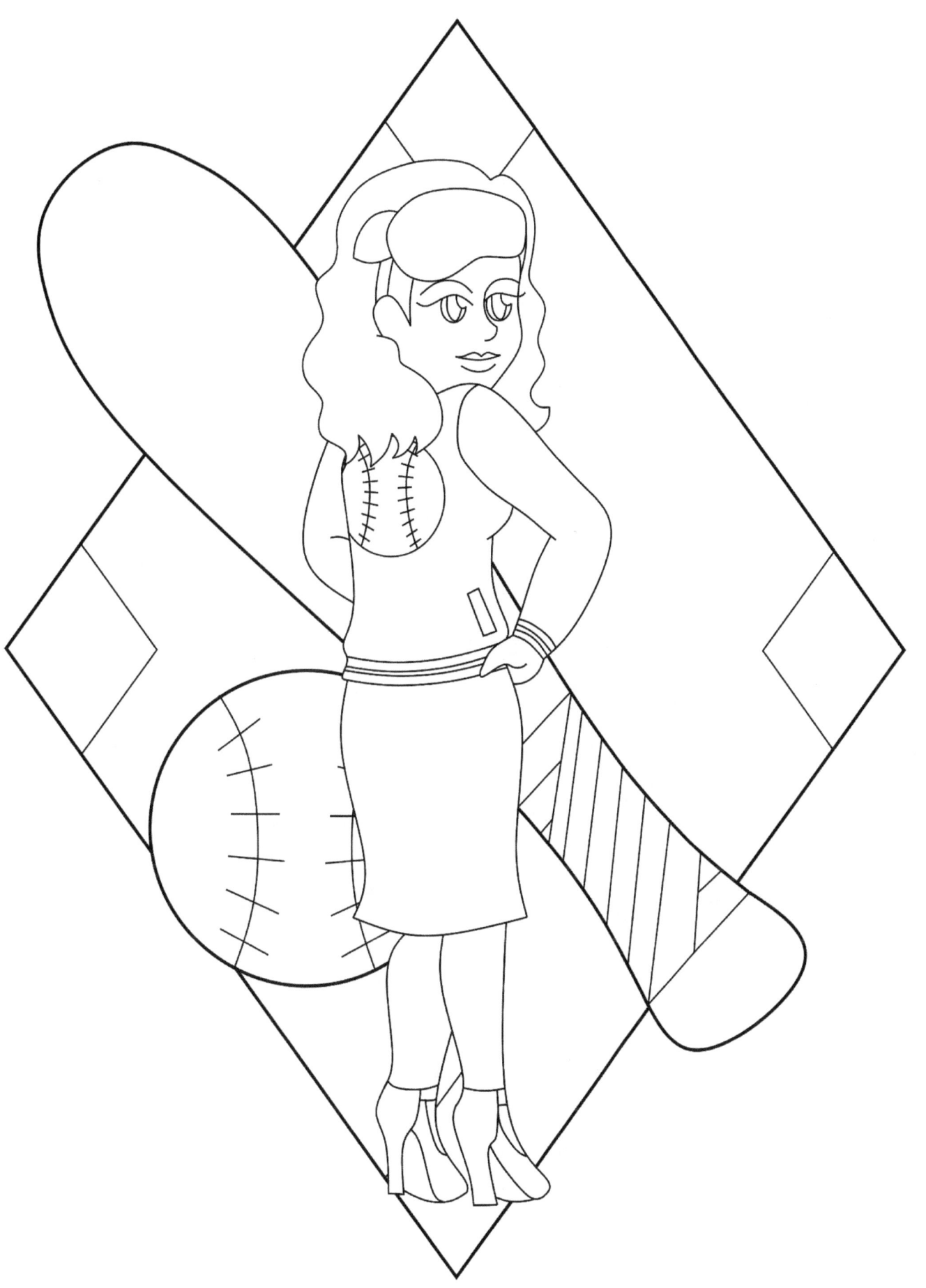

Copyright © 2016 M.J. Pennington/Orange Angels Studio

Copyright © 2016 M.J. Pennington/Orange Angels Studio

Copyright © 2016 M.J. Pennington/Orange Angels Studio

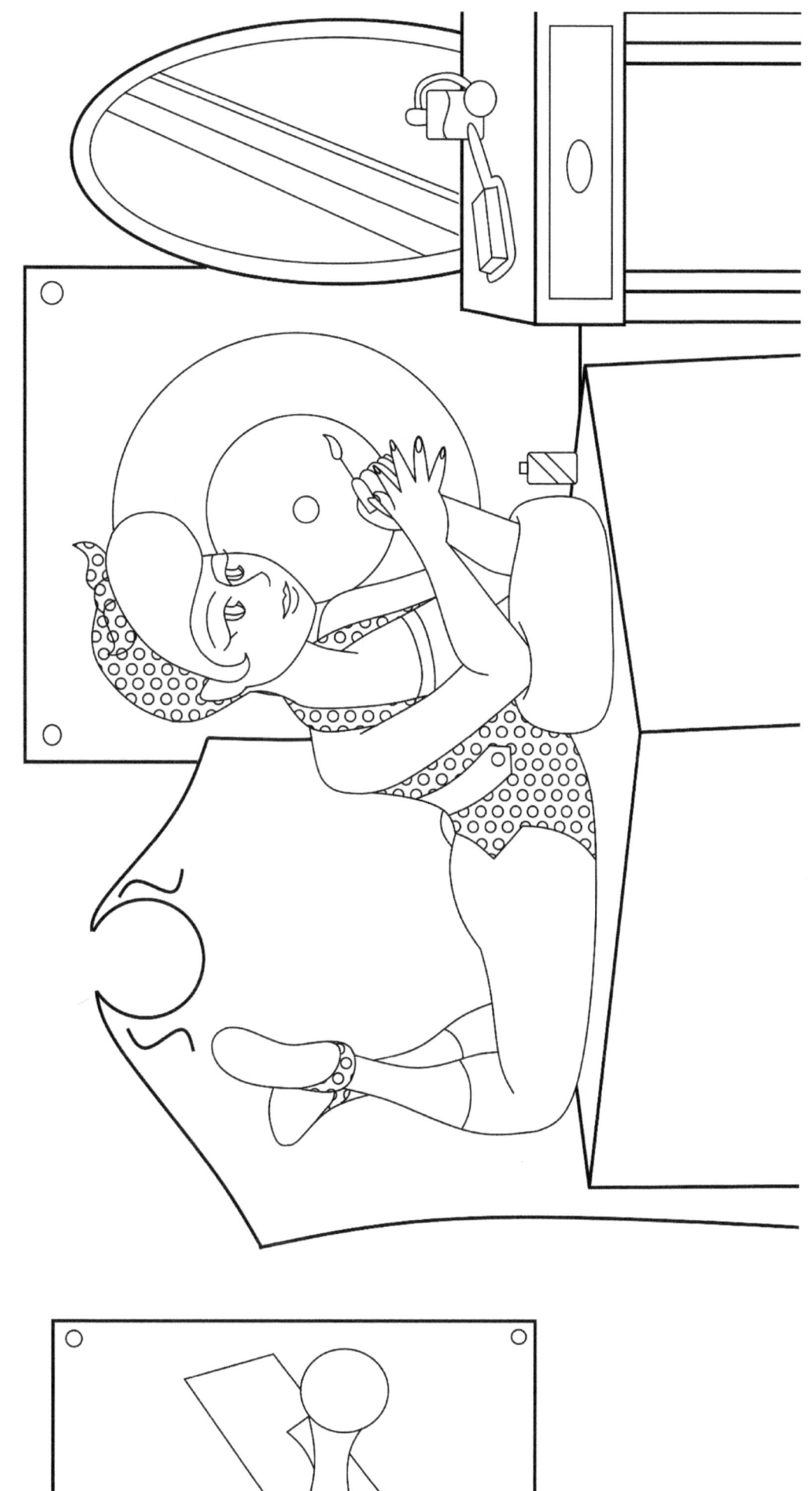

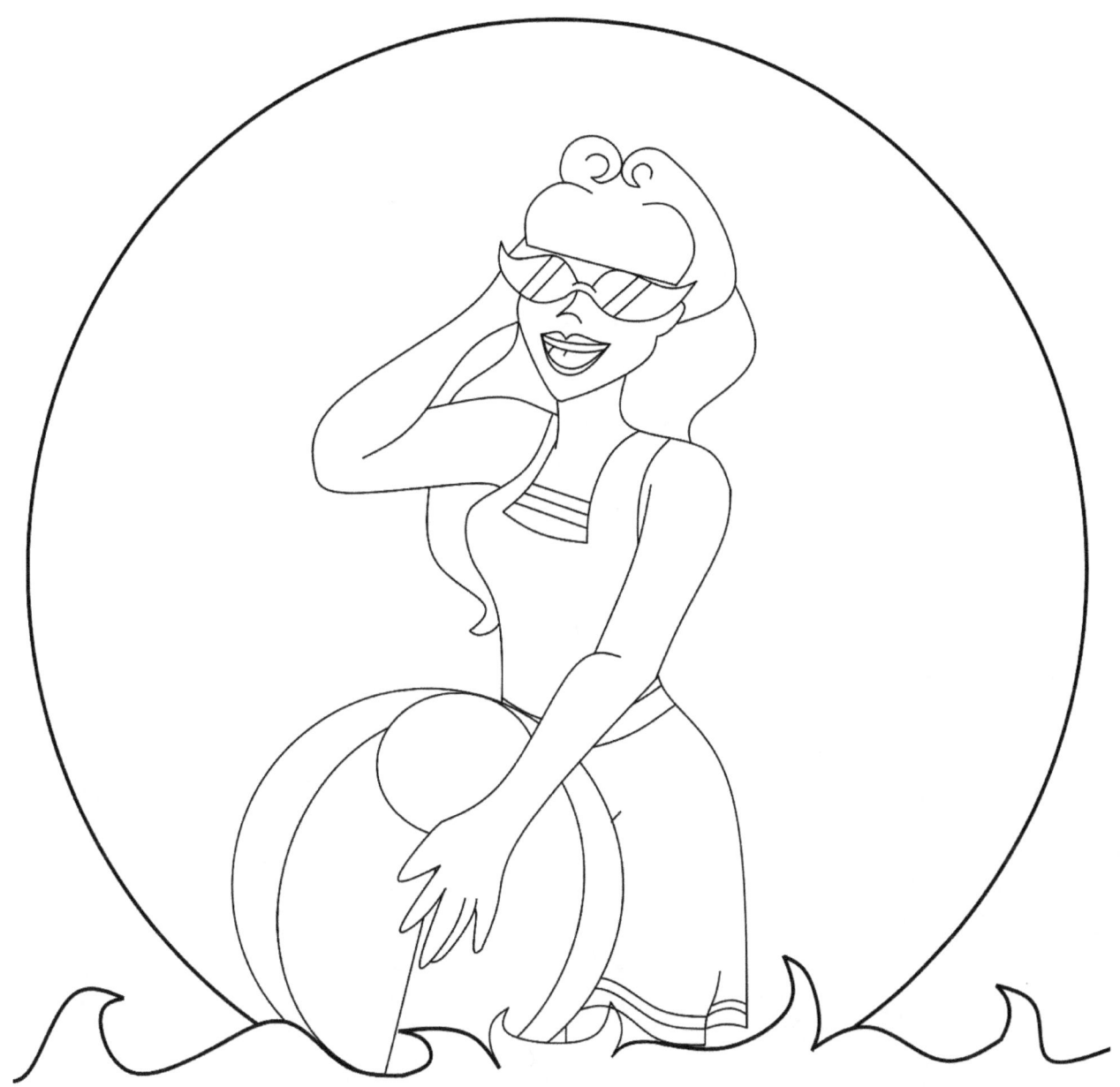

Copyright © 2016 M.J. Pennington/Orange Angels Studio

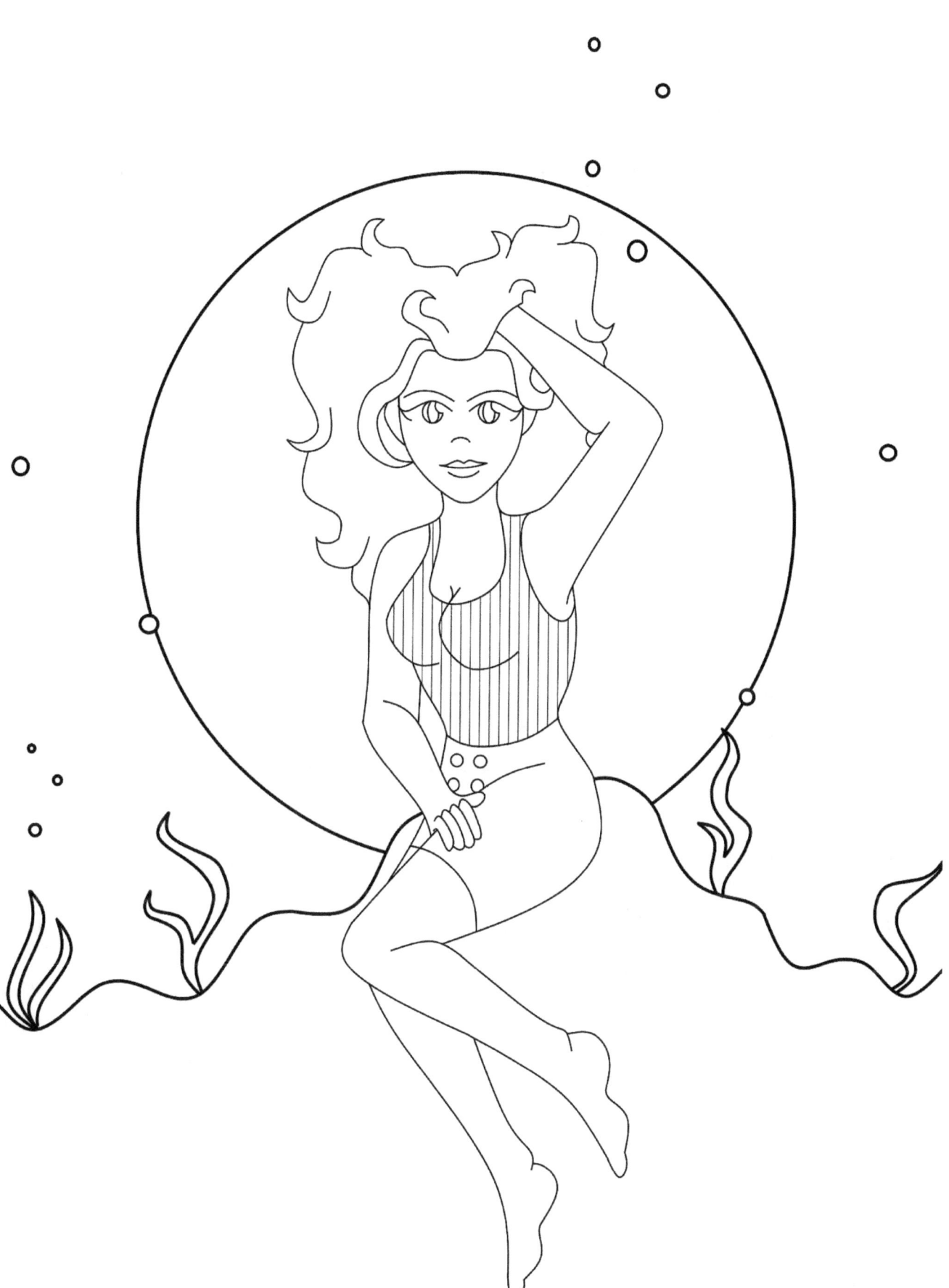

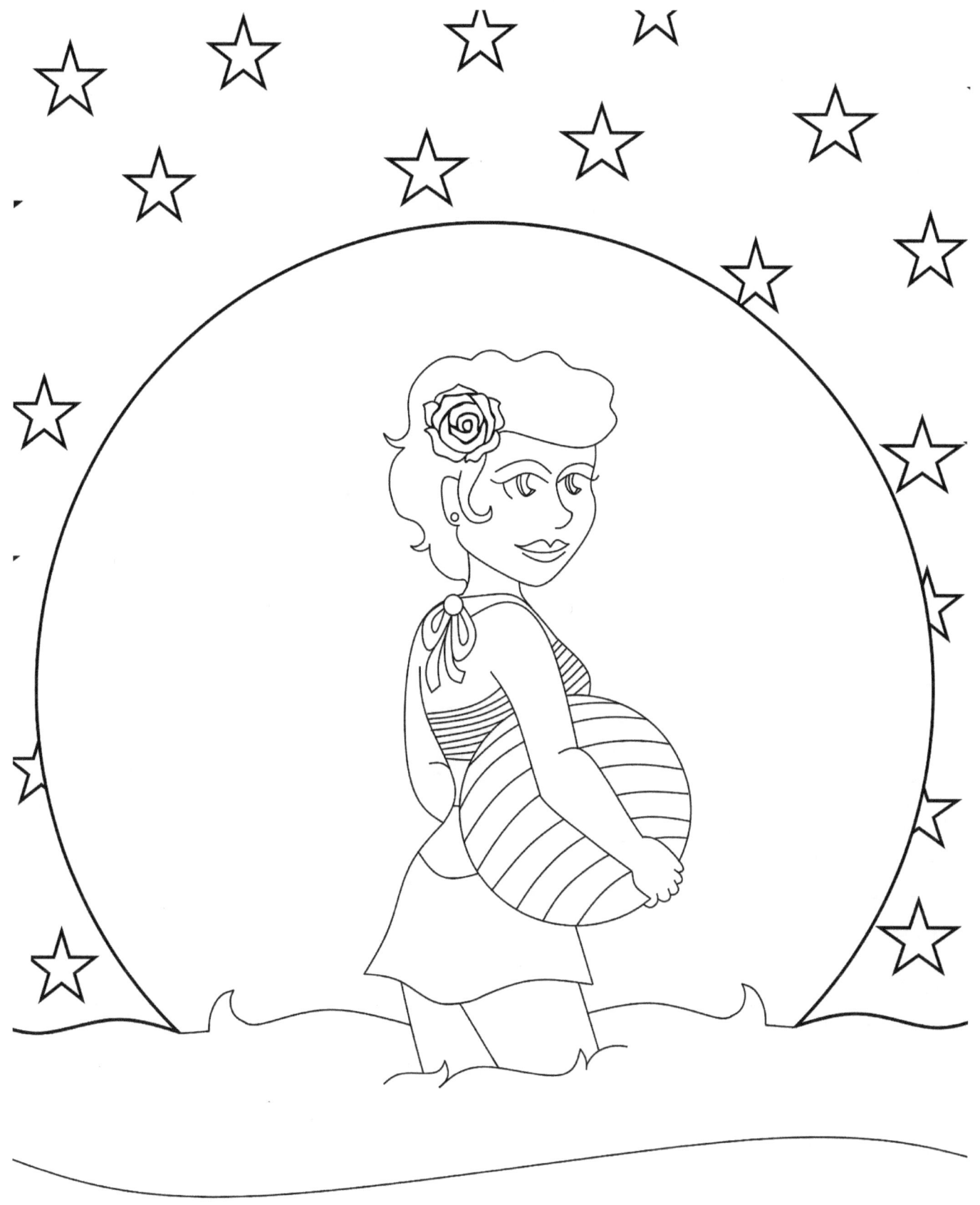

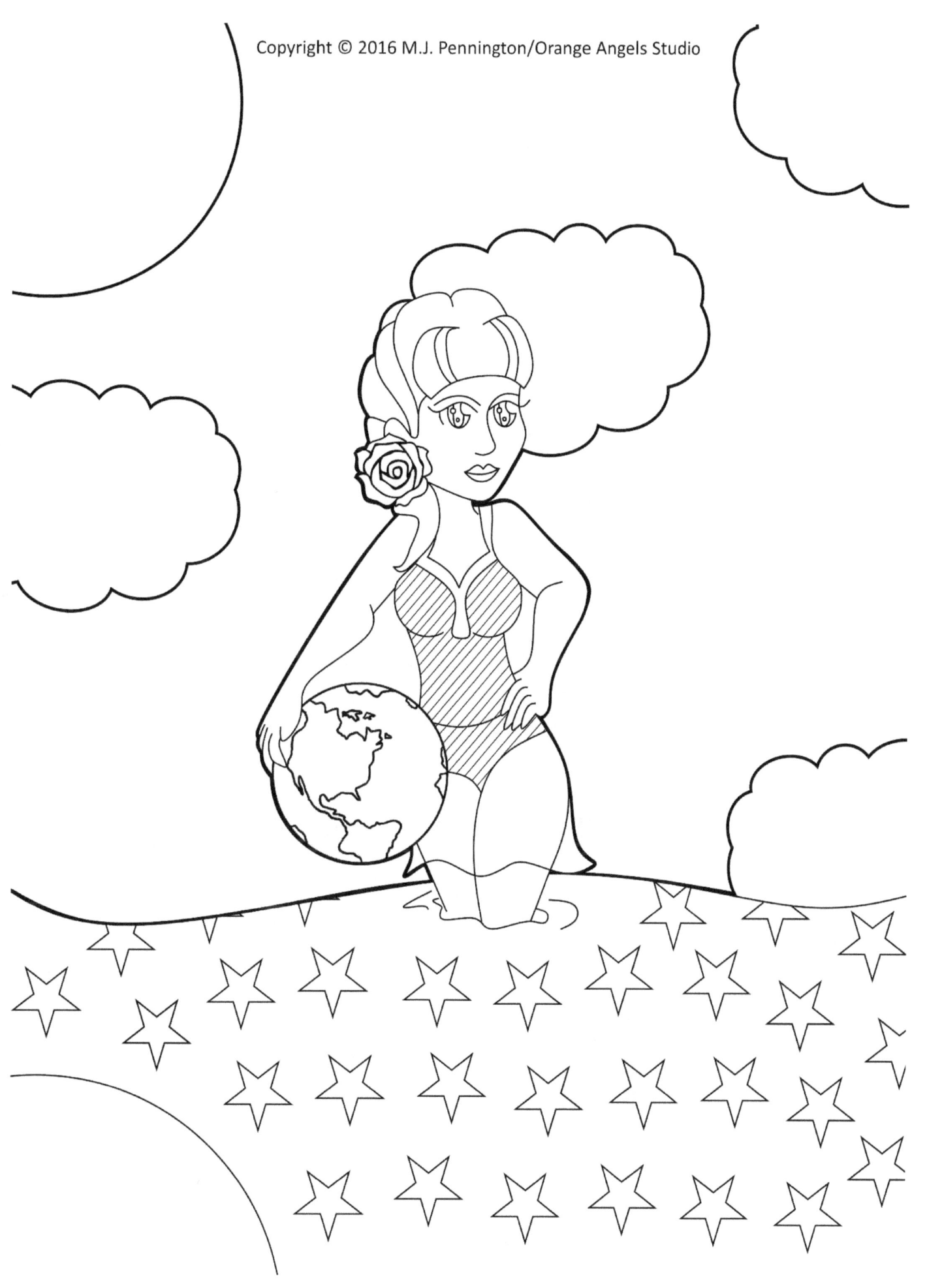

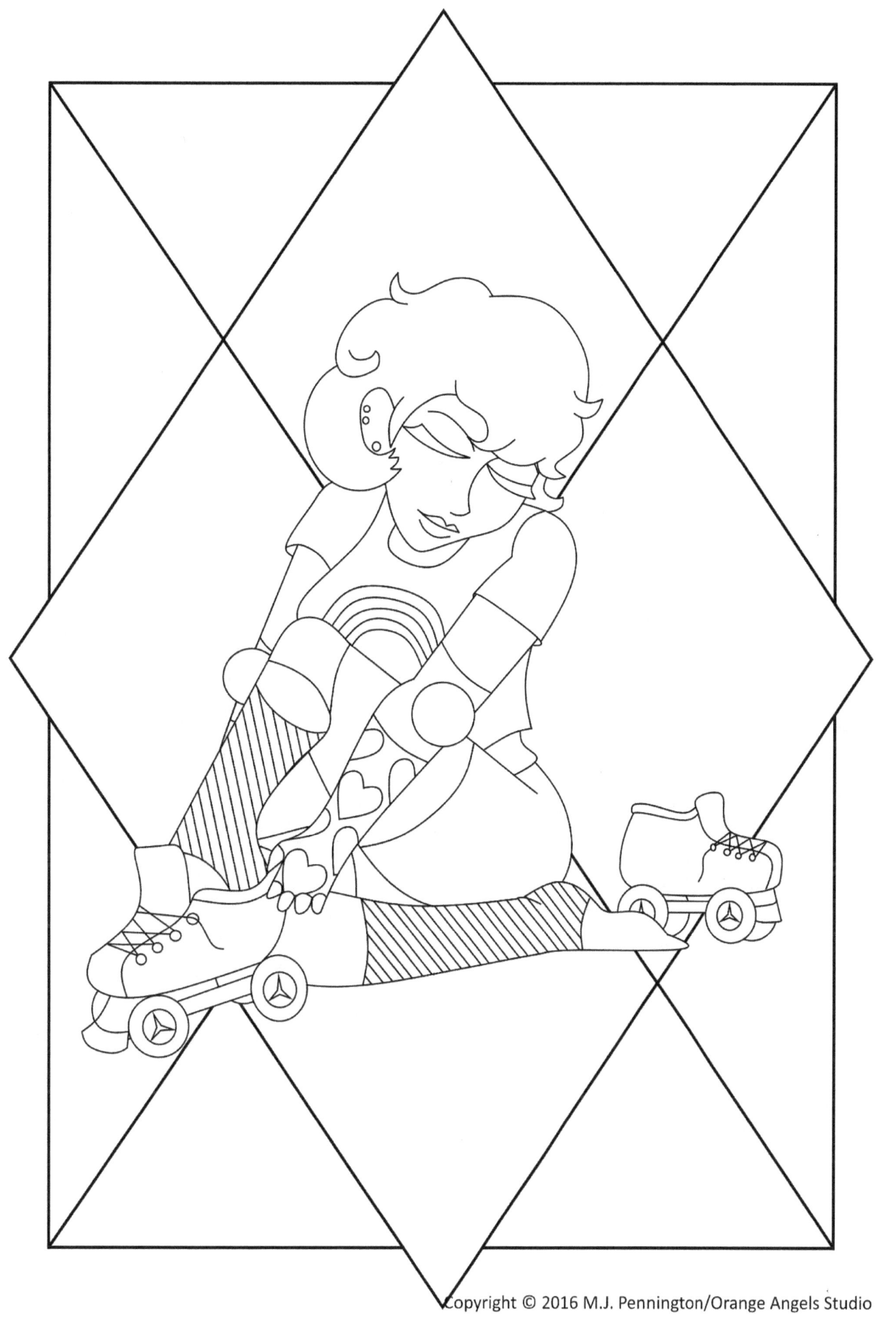

Copyright © 2016 M.J. Pennington/Orange Angels Studio

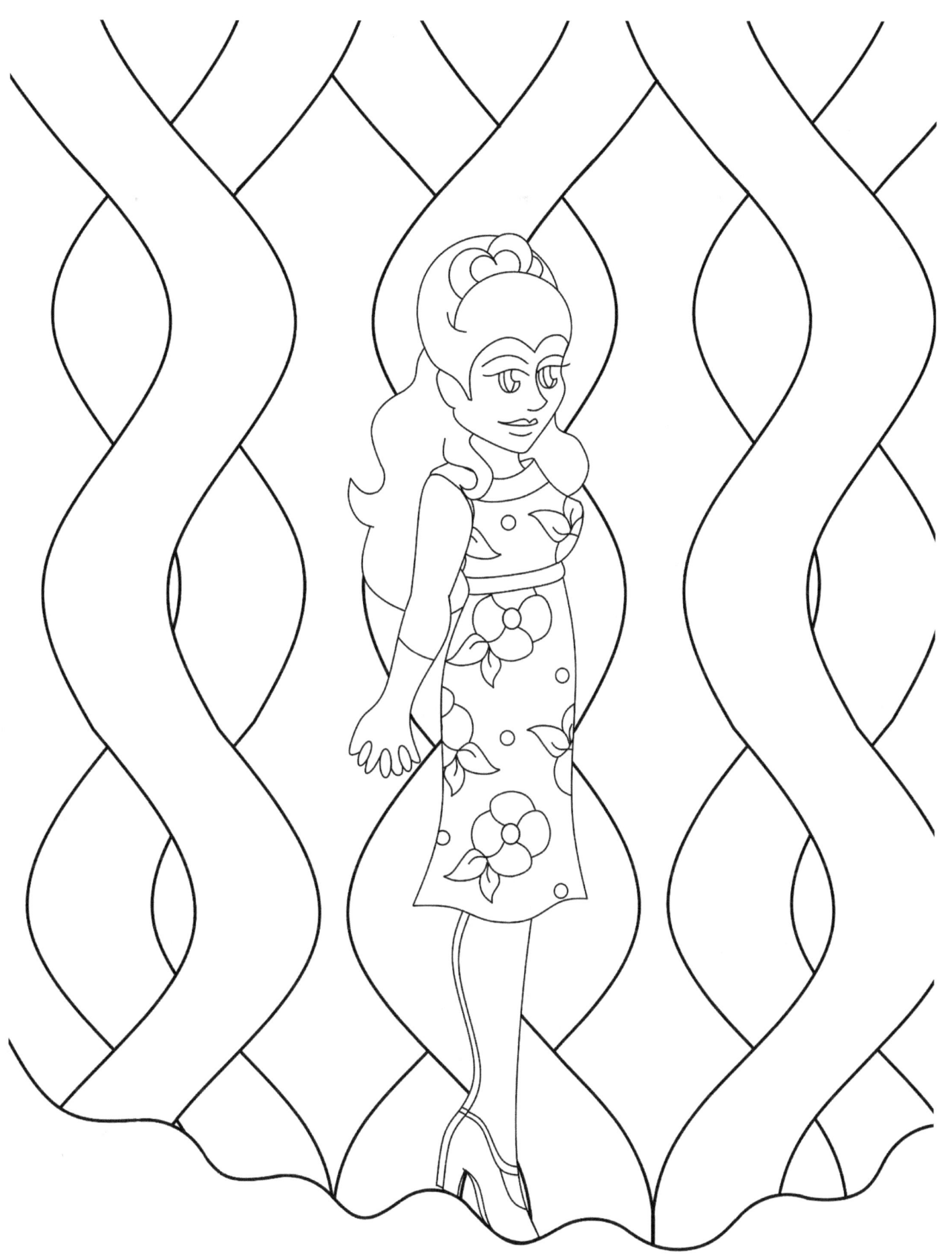

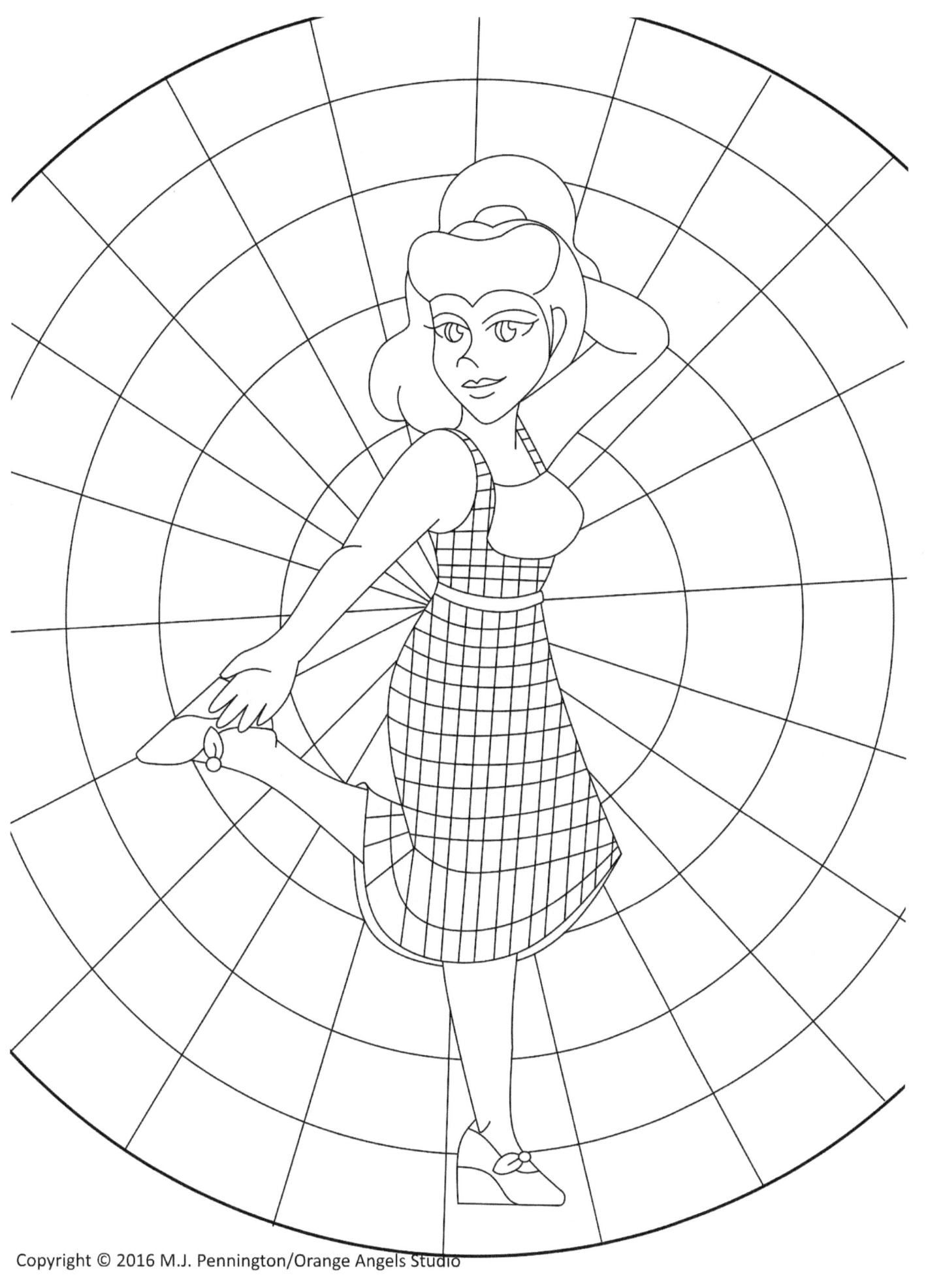

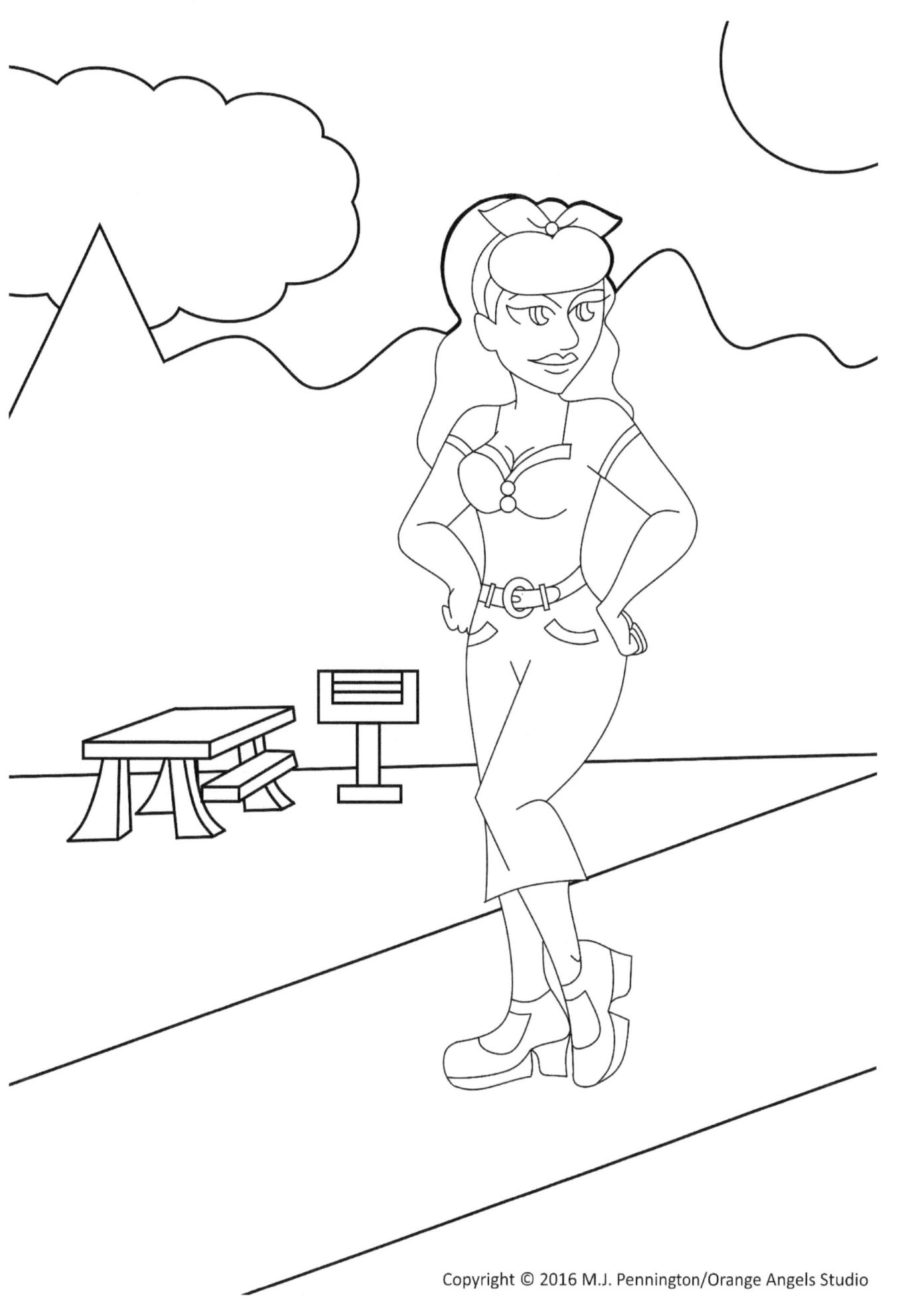

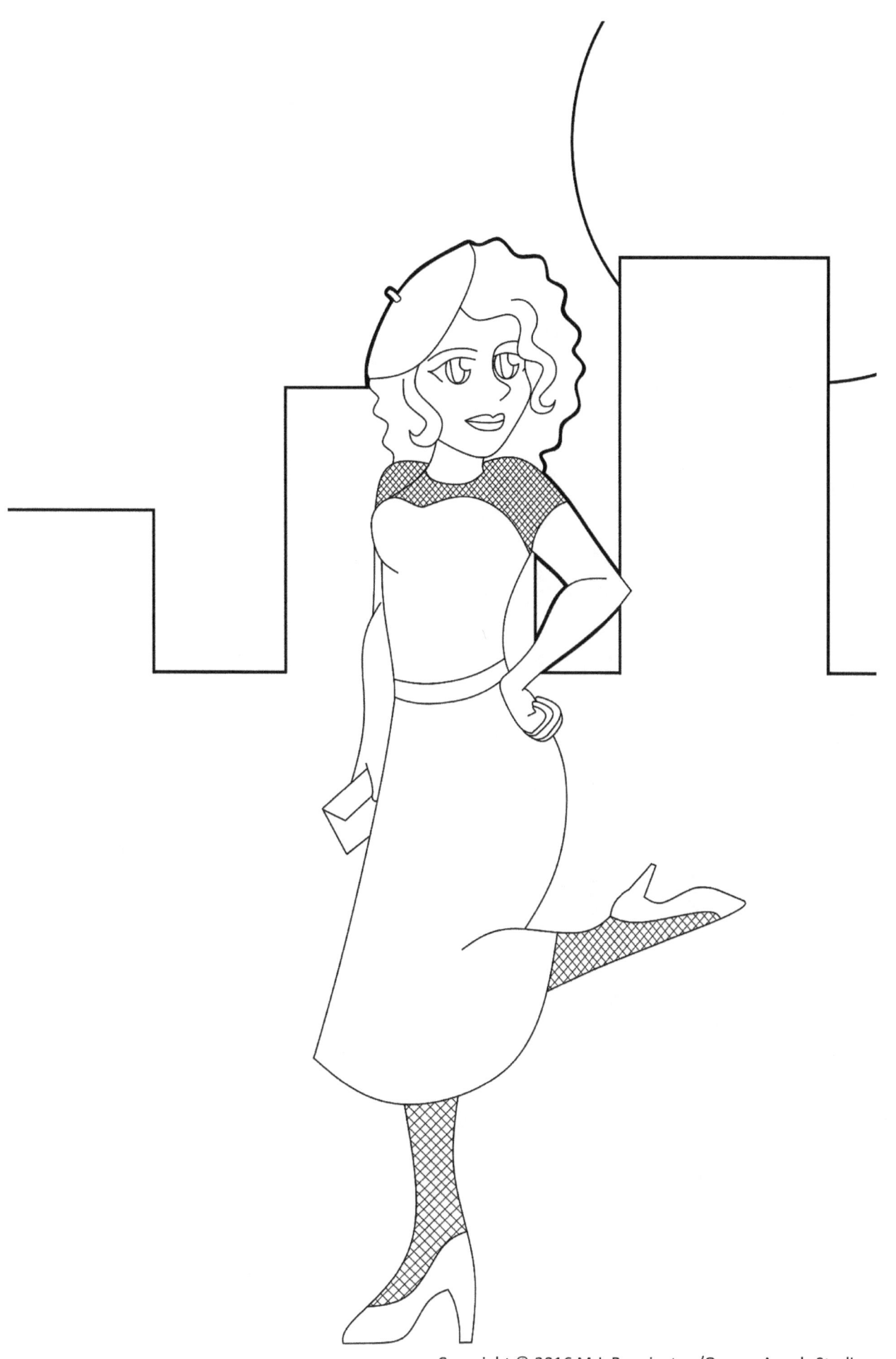

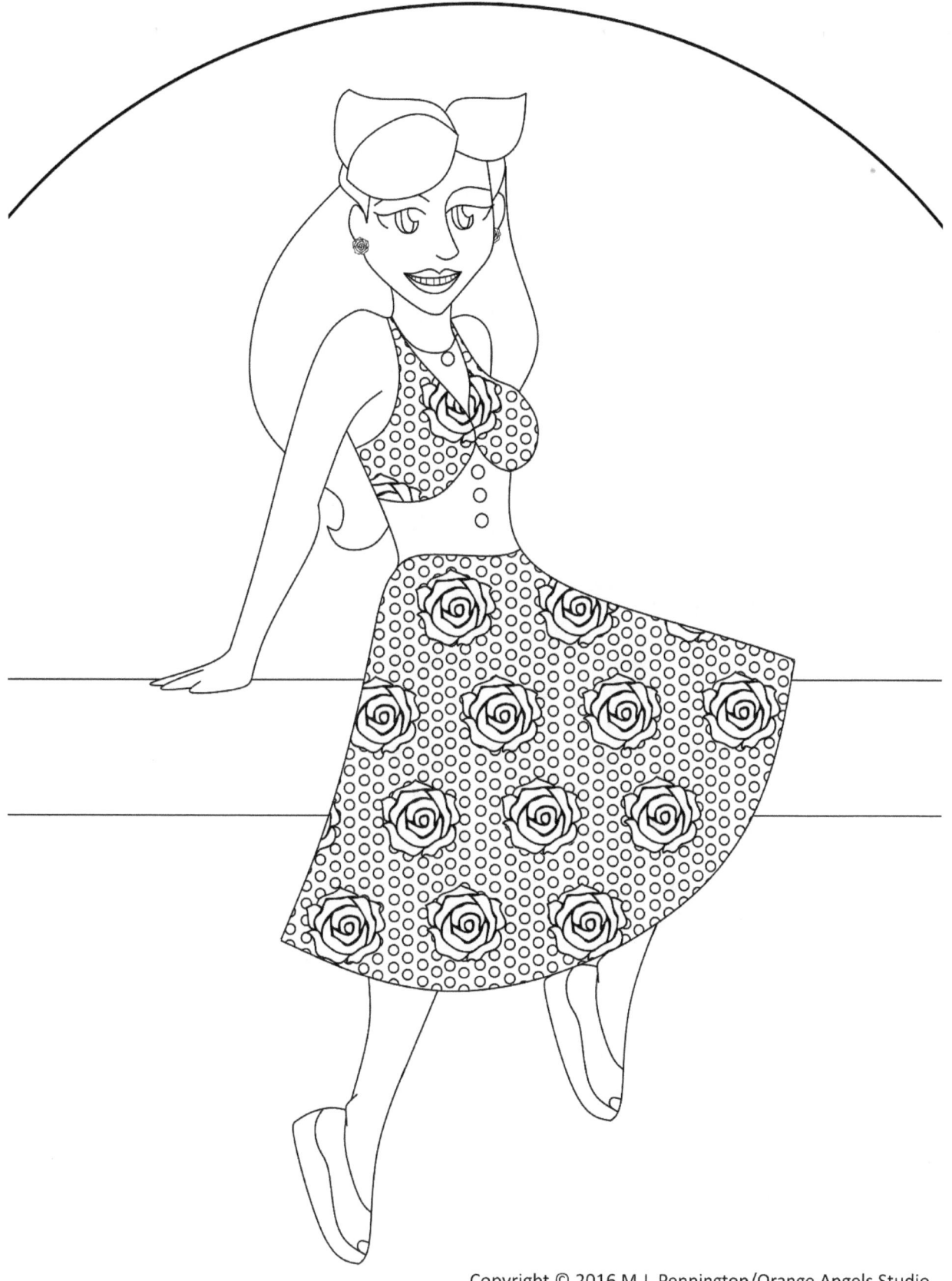

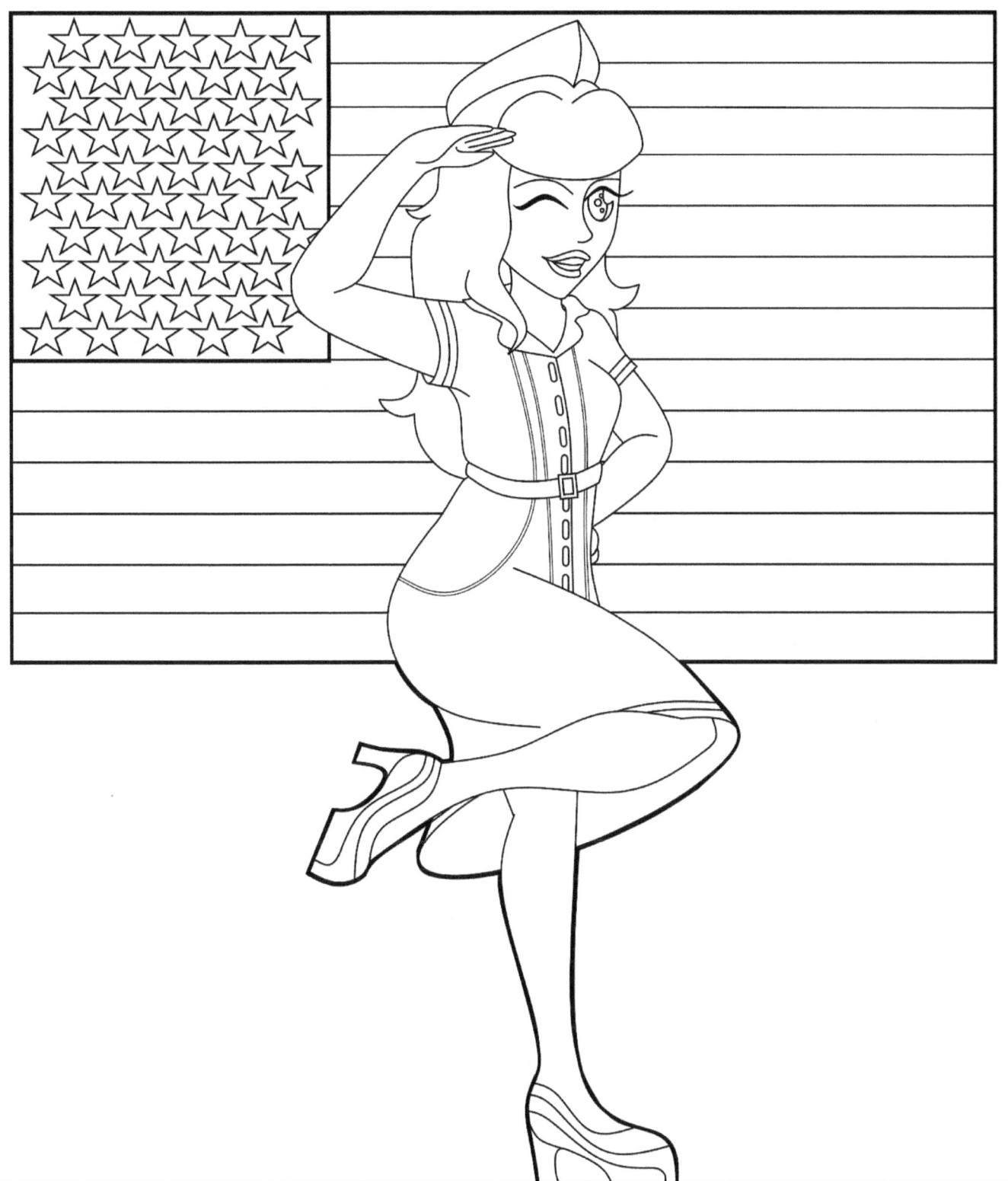

Copyright © 2016 M.J. Pennington/Orange Angels Studio

Copyright © 2016 M.J. Pennington/Orange Angels Studio

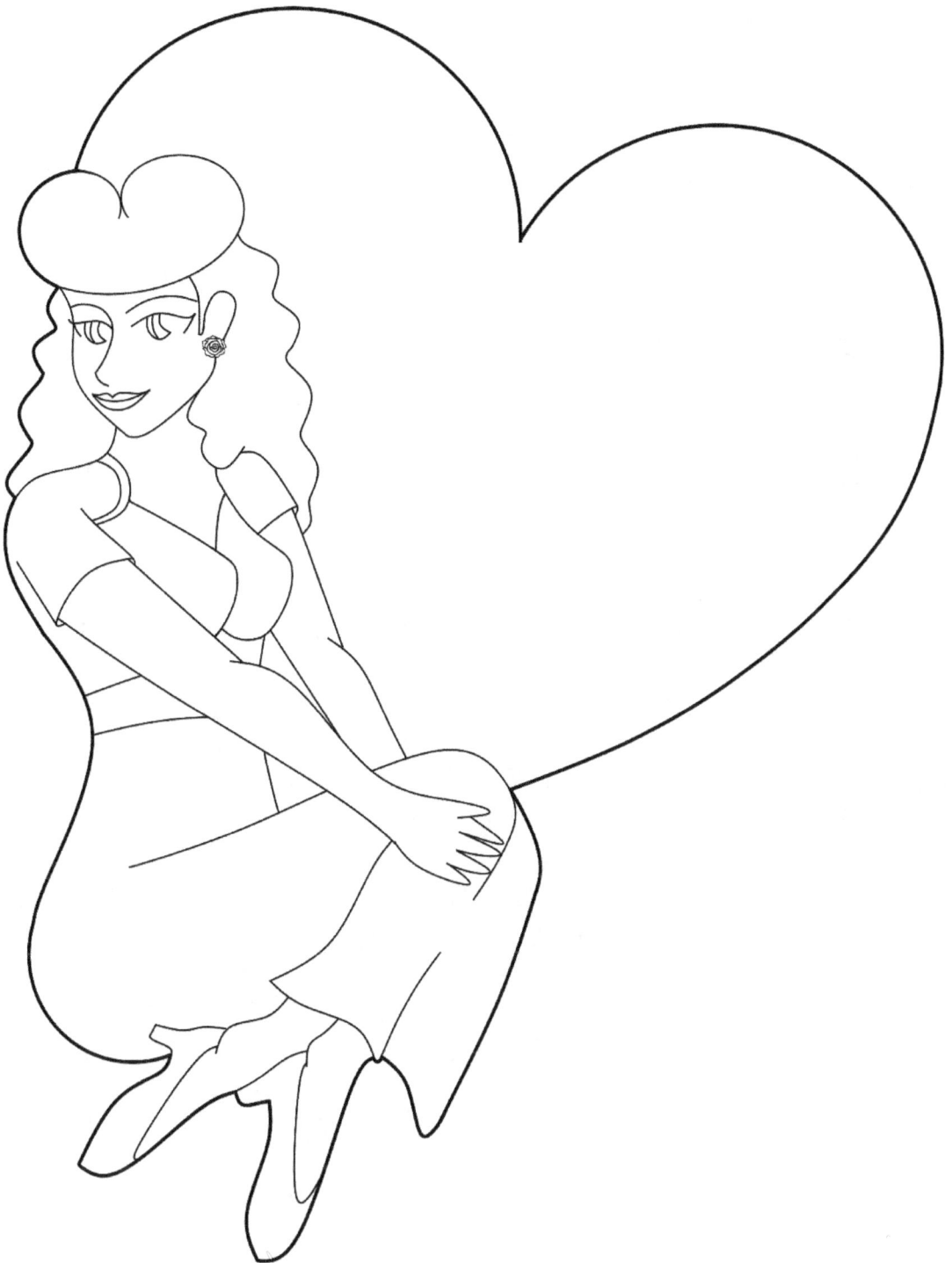

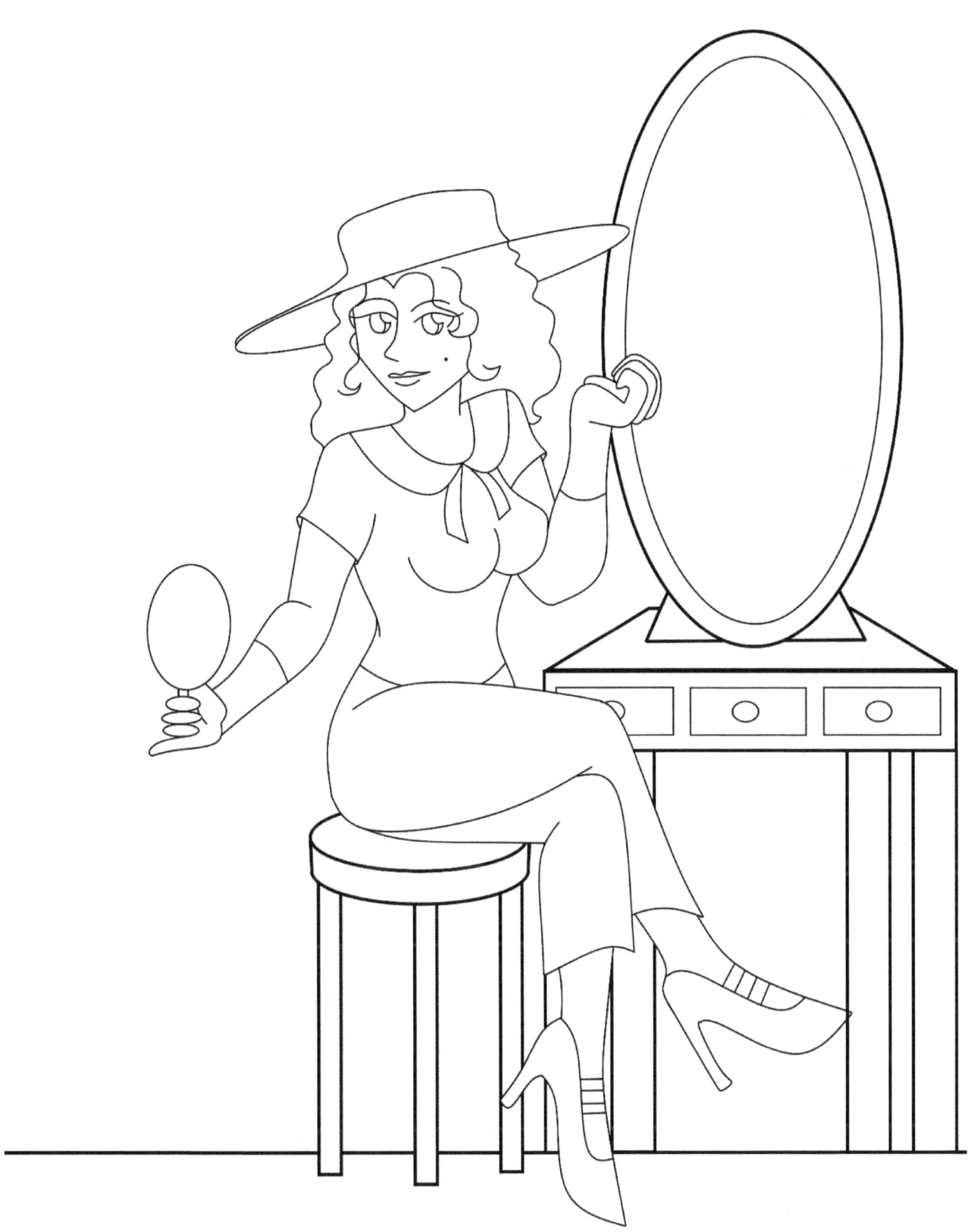

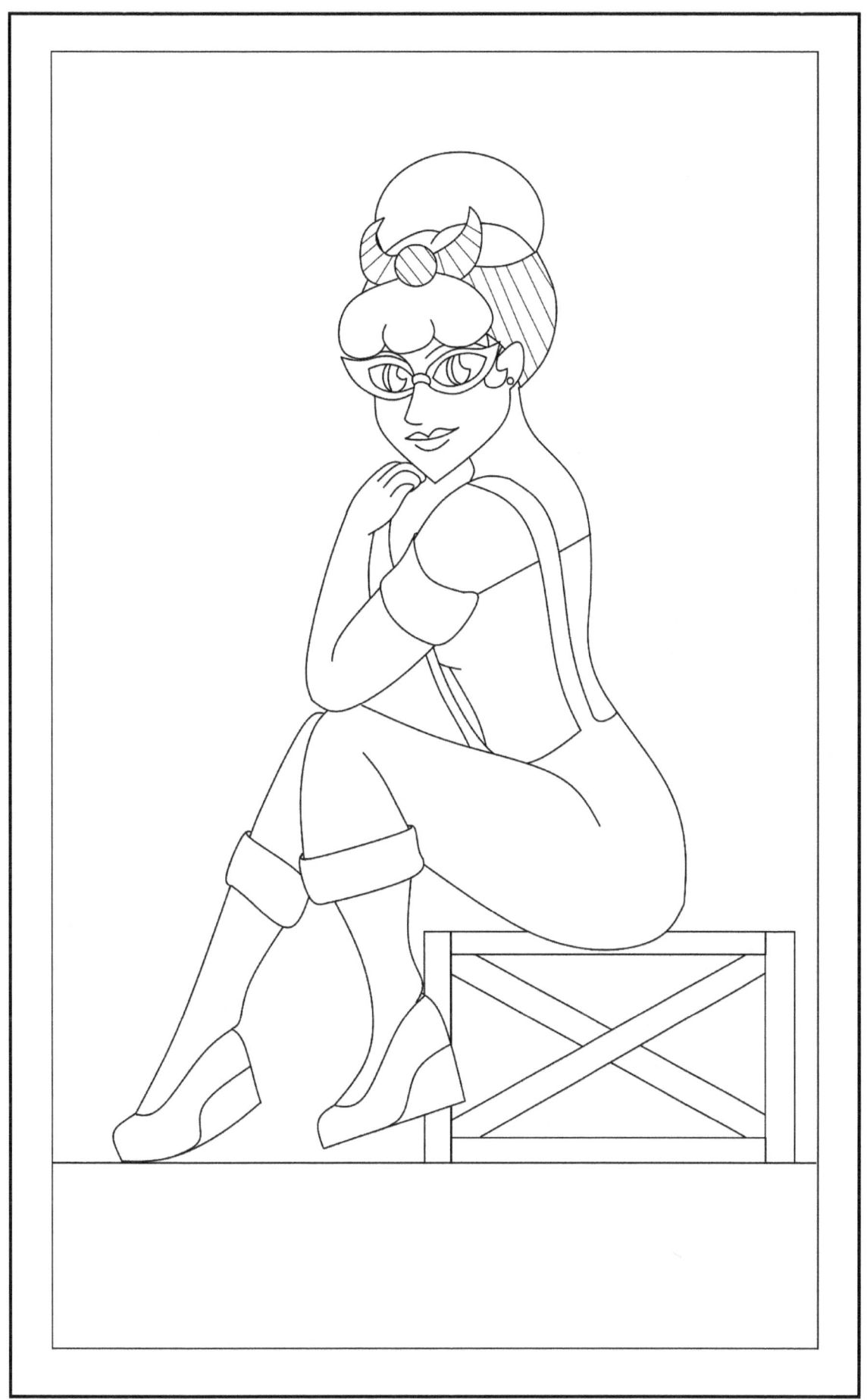

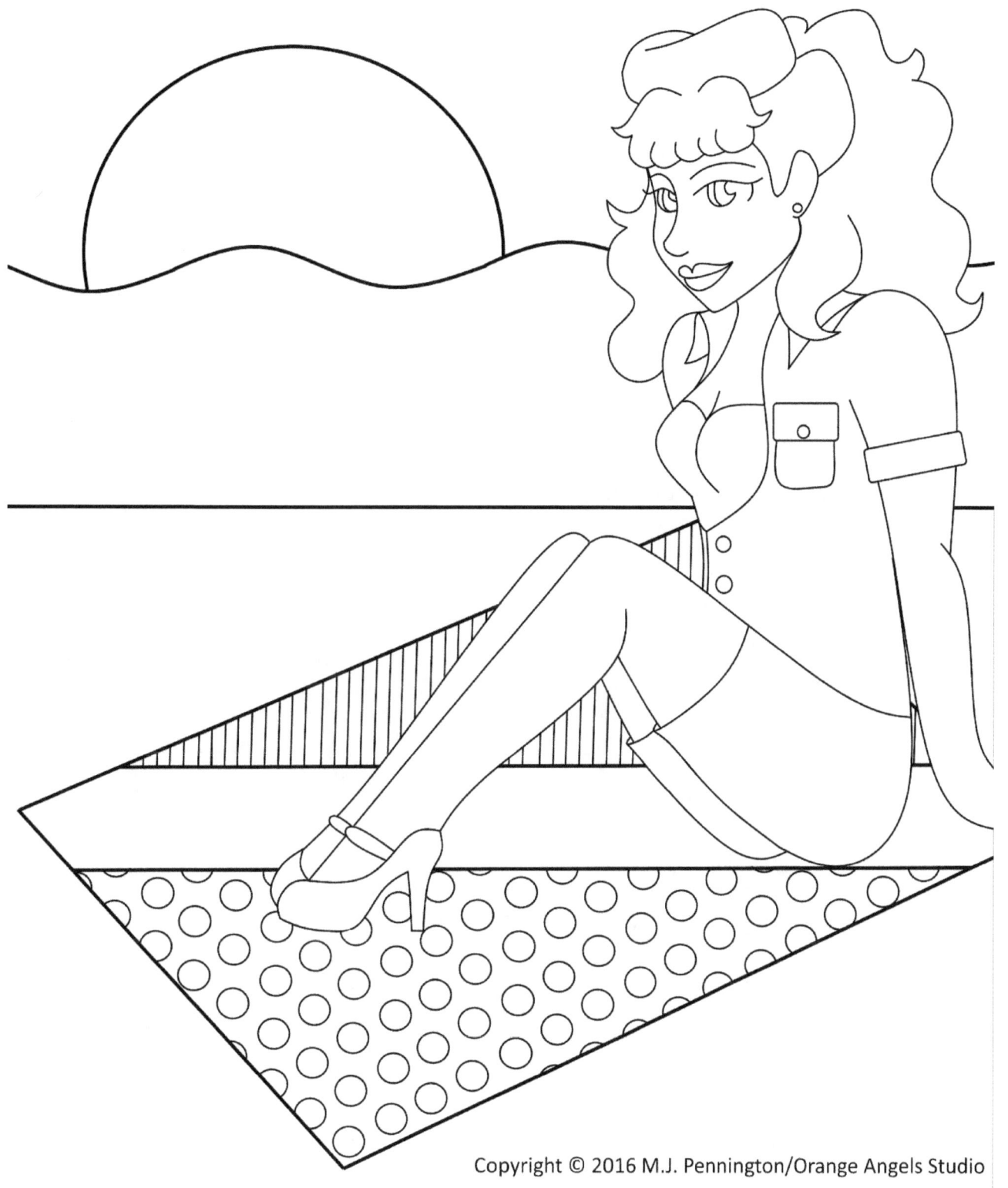

Copyright © 2016 M.J. Pennington/Orange Angels Studio

Copyright © 2016 M.J. Pennington/Orange Angels Studio

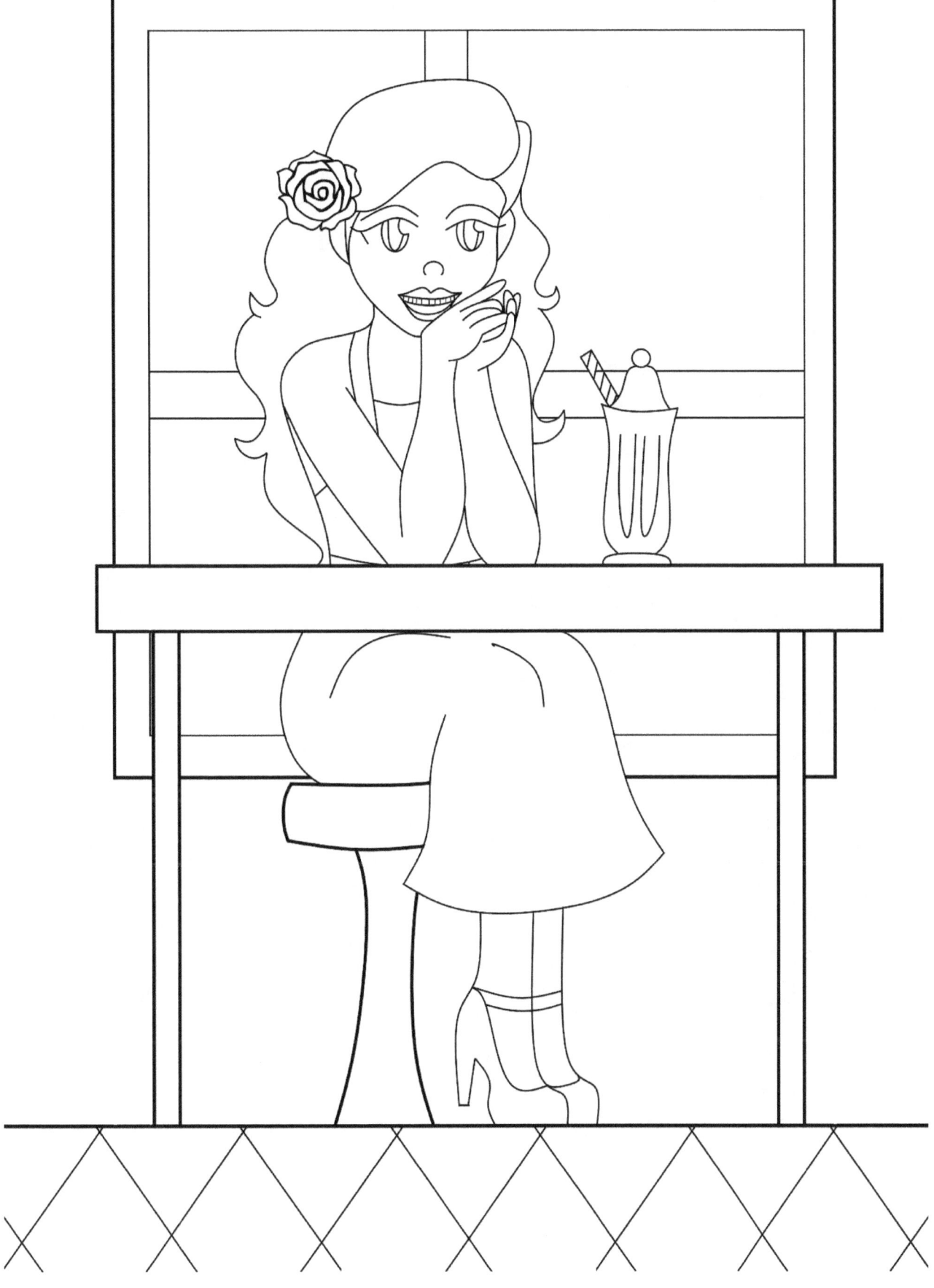

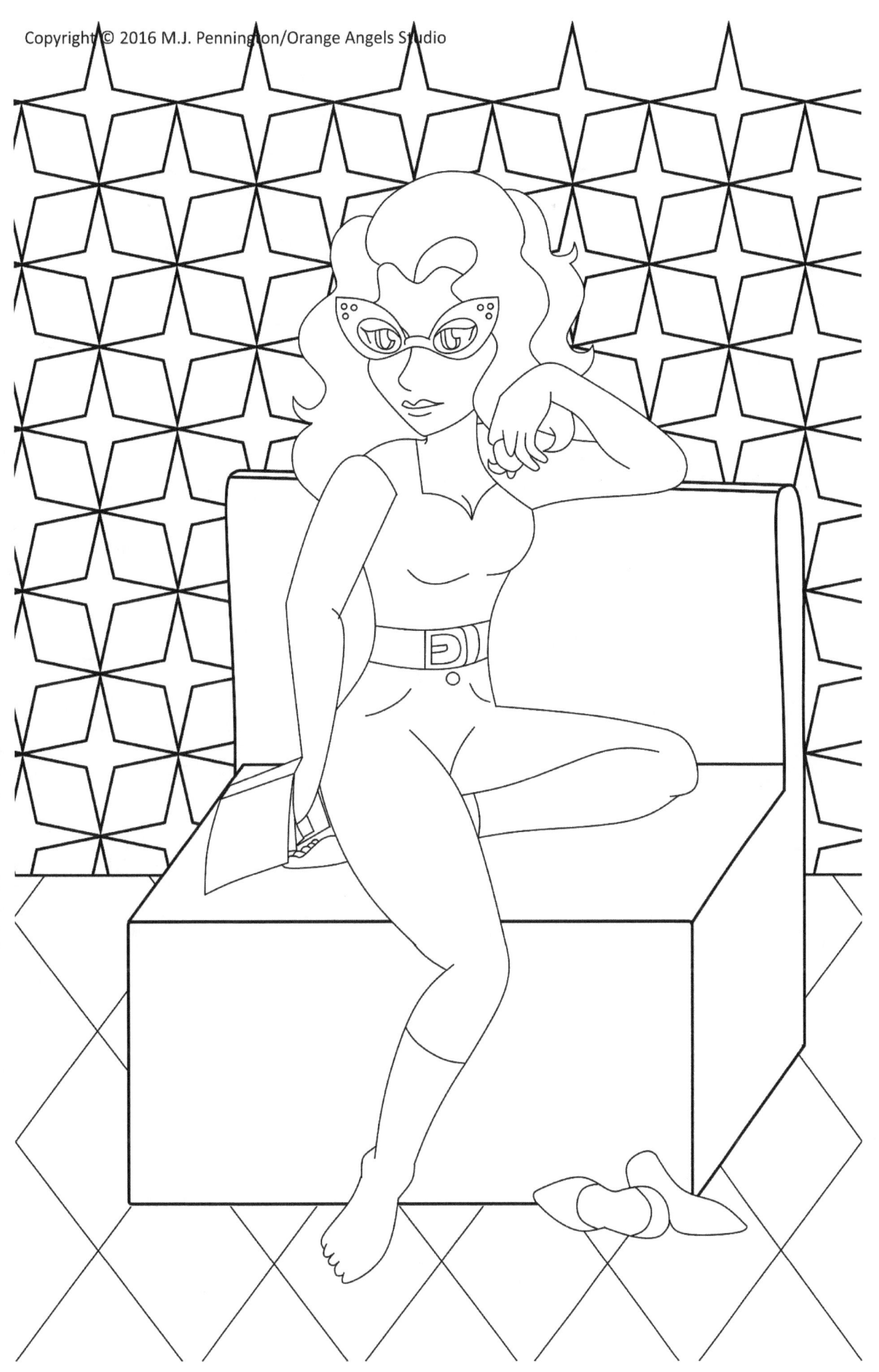

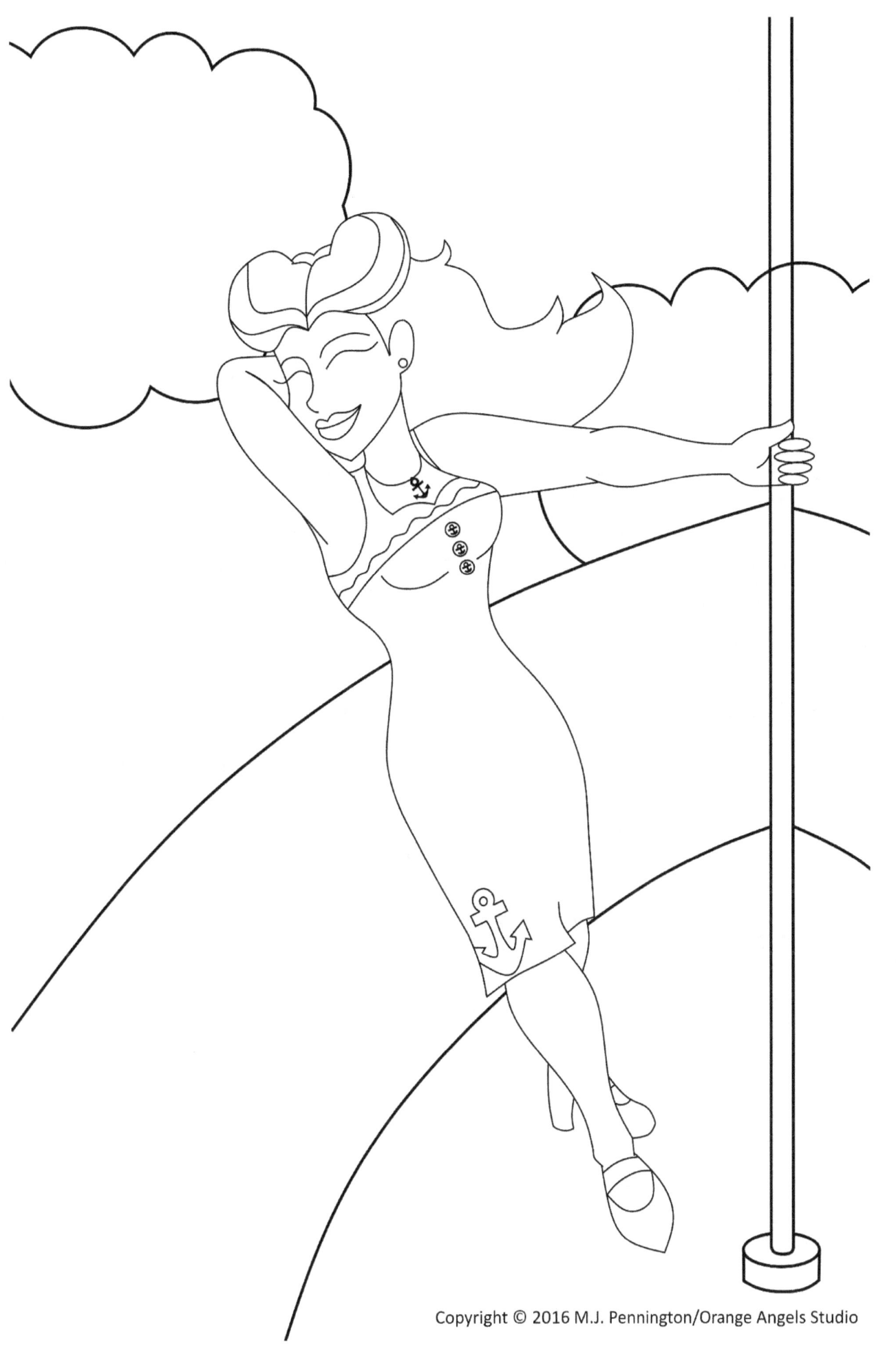

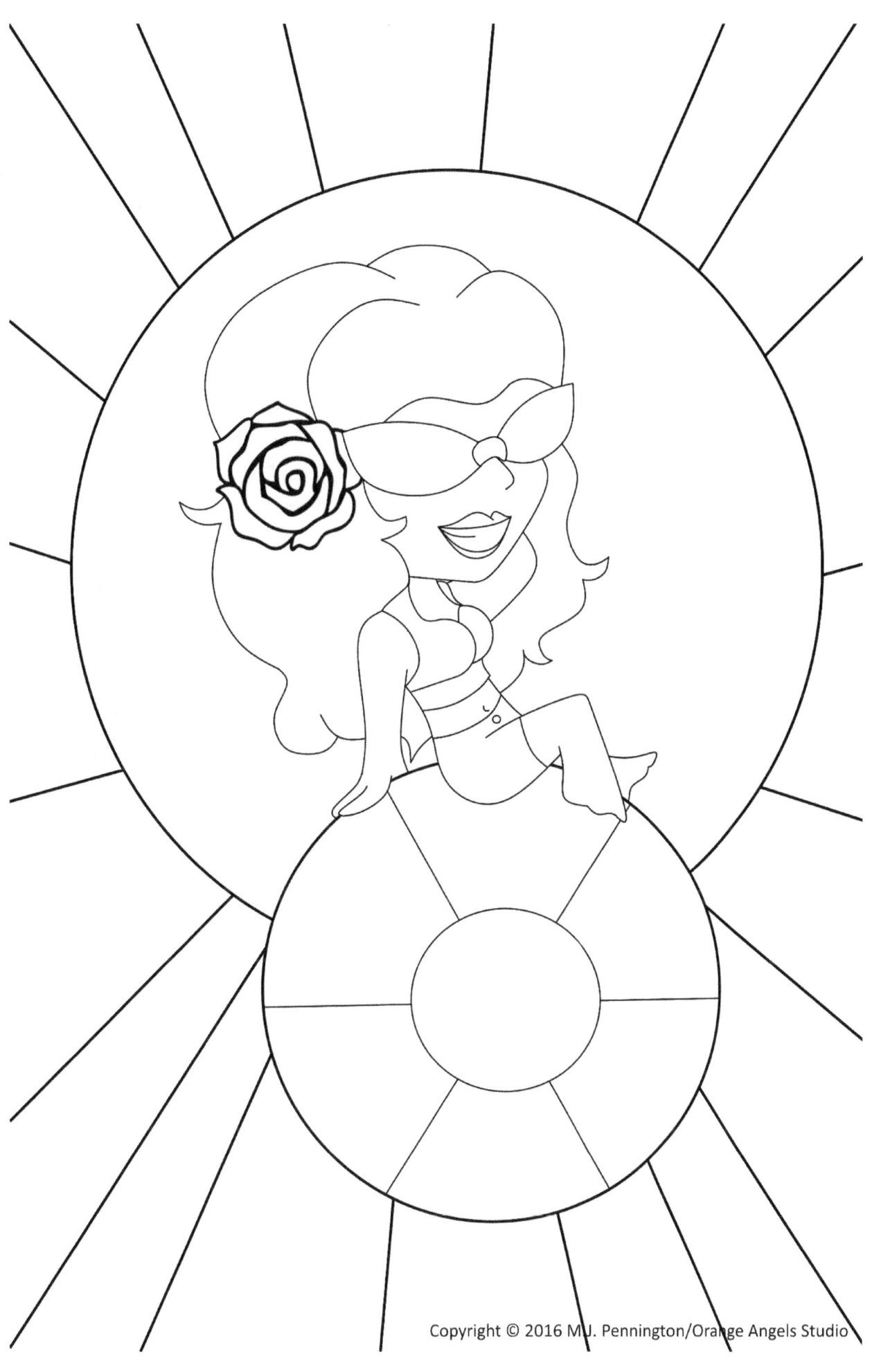

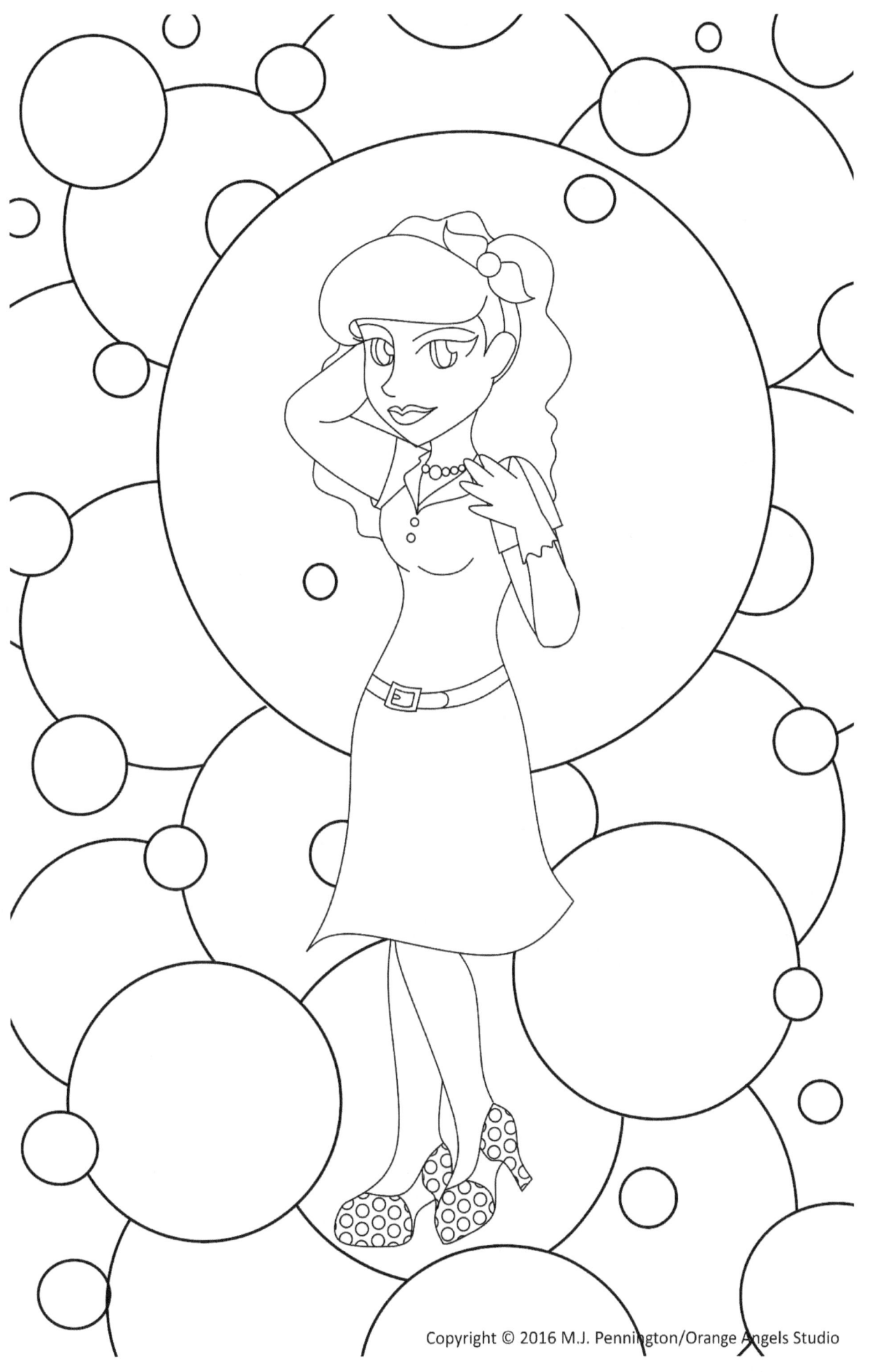

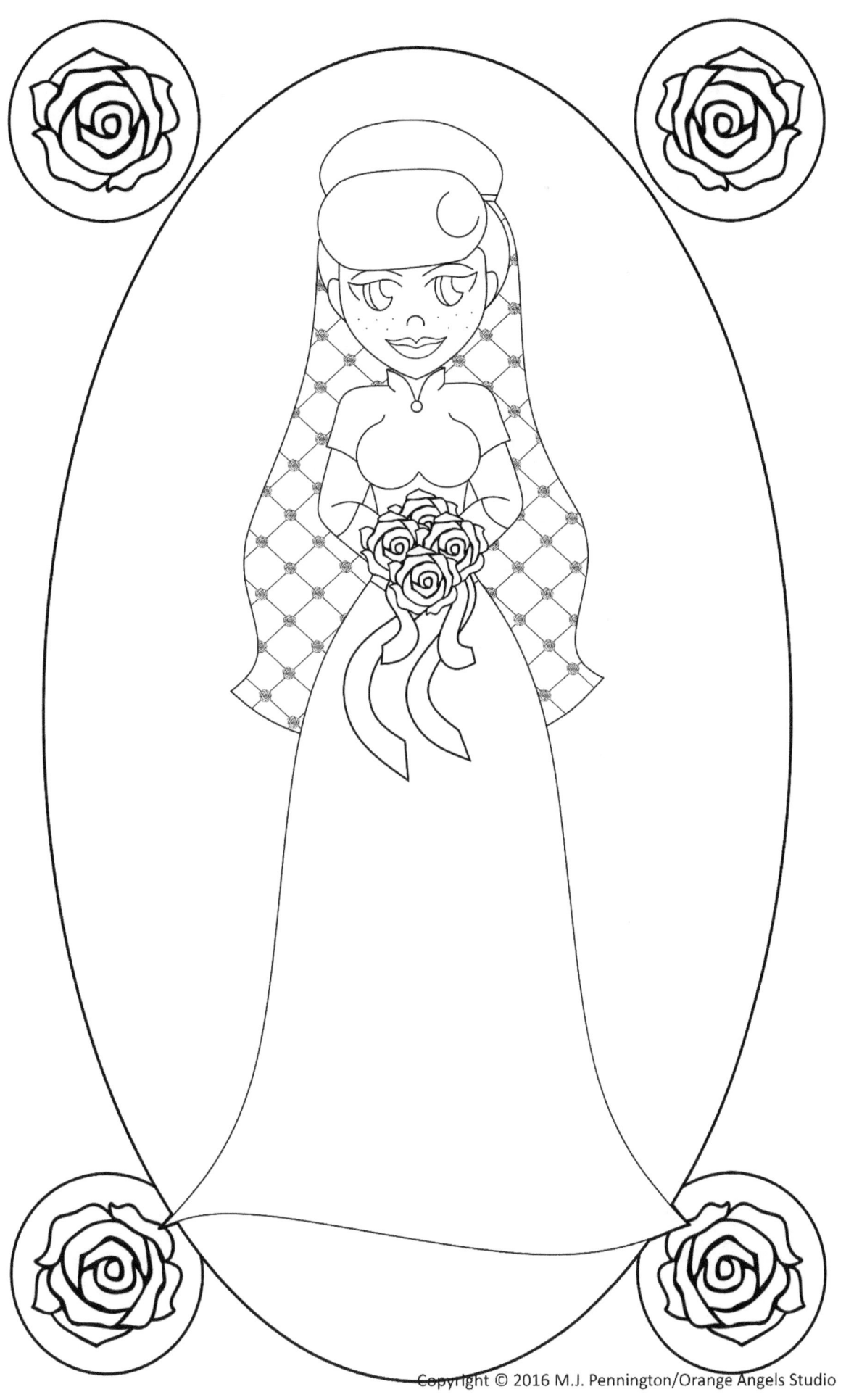

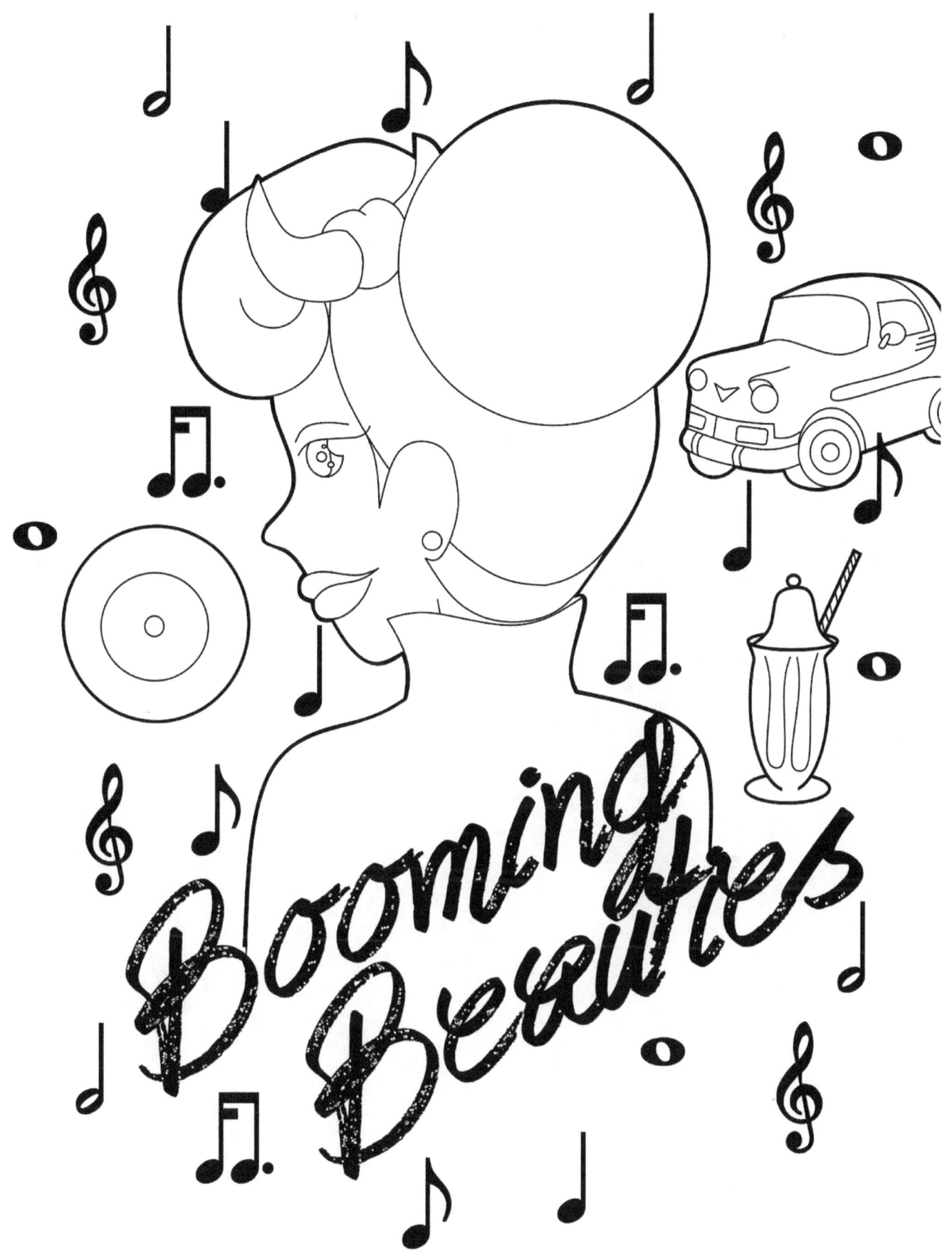

ABOUT THE ARTIST

M.J. Pennington

M.J. is a mom, artist, photographer, and cosplayer.

If you like this coloring book feel free to check out her pictures and other artwork on her studio page.

Orange Angels Studio
www.facebook.com/OrangeAngelsStudio